Rugby Site

WITHDRAWN

COLOURED PENCIL DRAWING TECHNIQUES

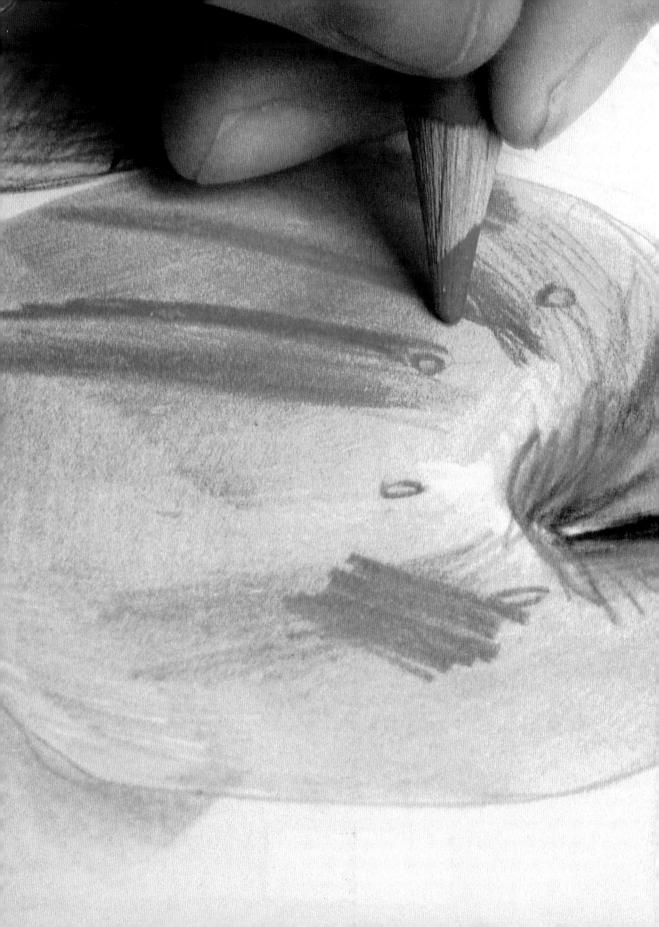

741.24 20003255 600016

COLOURED PENCIL DRAWING TECHNIQUES

lain Hutton-Jamieson

Eagle Editions

WARWICKSHIR LIBRA	
Class No: 741.21	+
Acc. No: 6,000 332	25
Date: 16 06	

A QUANTUM BOOK

Published by Eagle Editions Ltd 11 Heathfield Royston Hertfordshire SG8 5BW

Copyright © MCMLXXXVII Quarto Publishing plc

This edition printed 2004

All rights reserved.

This book is protected by copyright. No part of it may be reproduced, stored in a retrieval system, or transmitted in any form or by any means, without the prior permission in writing of the Publisher, nor be otherwise circulated in any form of binding or cover other than that in which it is published and without a similar condition including this condition being imposed on the subsequent publisher.

ISBN 1-86160-884-5

QUMCPT

This book is produced by Quantum Publishing 6 Blundell Street London N7 9BH

Printed in Hong Kong by Sing Cheong Printing Co. Ltd

CONTENTS

1	INTRODUCTION	7
2	MATERIALS	15
3	COLOUR AND	
	COMPOSITION	33
4	STROKES	39
5	HATCHING	57
6	CREATING COLOUR	77
7	COLOUR AND FORM	101
8	WATER-SOLUBLE	
-	PENCILS	117
9	SGRAFFITO	133
10	BURNISHING	143
11	IMPRESSED LINE	153
<i>12</i>	ANCILLARY TECHNIQ	<i>UES</i> 159
13	FIXING, MOUNTING	
(5)	AND FRAMING	167
	GLOSSARY	172
	INDEX	174

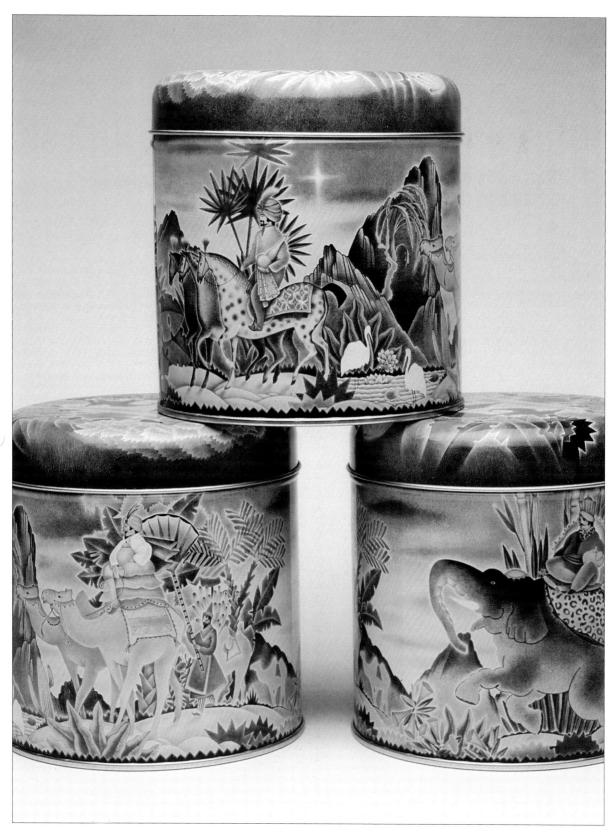

CHAPTER ONE

INTRODUCTION

The ability of a simple symbol to represent a complex notion, or even a story, makes images an essential means of communicating ideas. The style and craftsmanship of the artist combine with the drawn image to strengthen the message it puts across.

Colour offers the artist and viewers yet another level of experience—another language. When the vast choice of drawing techniques is supplemented by colour, an enormous array of possibilities opens up in the depiction of an image. Not only are the techniques of creating colour in drawing very different from any other medium, but the processes of analytical thought in producing the drawing suddenly alter.

Coloured pencil drawings are no longer the domain solely of children, nor are they regarded merely as preparatory stages in the execution of a work of art. Today they are a popular medium for illustration, particularly in the area of packaging. The images reproduced on these Christmas tins, *left*, were drawn by Jenny Tilden-Wright.

THE DEVELOPMENT OF THE COLOURED PENCIL

Until relatively recently, it was unusual for drawings to be produced for purely aesthetic purposes. Because they were used as a means of study, such as Leonardo da Vinci's drawings were, or as preliminary sketches to be developed further in paintings or sculpture, drawings were regarded as a secondary medium in relation to the painted or finished work. It was not really until the mid-eighteenth century that drawing became an art form in its own right.

About two centuries earlier crude drawing materials had been refined into finely bonded substances which led to the production of graphite 'leads' - lengths of bonded graphite particles. (Graphite is the crystalline form of carbon and is not in fact a 'lead' at all - at some point in history it was referred to as black lead and hence the rather misused terminology we still refer to today.) These bonded substances could be moulded into any desired width, and to prevent them from rubbing off on the artist's hands casings were soon developed for them. Fairly complex pencils were made with leather or metal casings, but it was not until much later that wood-cased pencils became widely available. Even more recently, coloured pencils have appeared on the market. They are made in exactly the same way as graphite pencils are, but the 'leads' are made from pigment particles suspended in a bonding agent. The quality of the coloured pencil is directly related to the quality, or purity, of the pigment, its density within the lead and the quality of the bonding agent.

Today we make wooden pencils along much the same lines. A quantity of coloured pigment is bonded in a waxy agent and shaped into a thin rod, like a 'lead'. Grooves are cut down a flat piece of wood at close but regular intervals. A coating of adhesive is then applied to the wood and the pencil leads are fitted into each groove. A duplicate strip of wood is then stuck on top of the leads, effectively embedding them in a sandwich of wood. The wood is then carefully cut from around each lead to form a pencil; some are cut with a circular casing and others with a faceted casing, the idea being that the flat sides will prevent the pencil from rolling and possibly falling, thereby damaging the lead. The pencils are painted and varnished and any necessary information is printed or embossed on the sides. The pencils

are then sharpened and boxed.

The development of coloured pencils is not only a natural progression in the evolution of drawing materials and techniques but also a further indication of the movement of drawn illustration into the realm of art. The opportunity to draw in colour enables us to create pictures that have an even greater instructional value than monochromatic studies do or which simply have an aesthetic charm that has previously been overlooked.

WORKING WITH COLOURED PENCIL

Coloured pencils are some of the most controllable materials available to produce an image; they therefore offer great scope for precision and for producing an accurate representation of your subject. They and the materials used with them – papers, erasers, fixatives, sharpeners, etc. – are also easily transportable. This means that they allow you to capture a scene or image spontaneously, or can be an immediate form of notetaking to be used later as reference for a more elaborate or finished work.

There are numerous marks that can be made by coloured pencils on paper to enhance the effect you want to achieve. Moreover, the ways in which your coloured pencil may be held, sharpened and moved, and the paper you use, all enable you to create further levels of interpretation within your work. The lines you make, for example, are extremely important – they may be directional (up, down or sideways) and may take the viewer's eye into the picture, or out of it, or they may create areas which are placid or full of turmoil. There are as many drawing techniques as there are effects and only by studying and practising the possibilities will you realize the potential in your image.

The surface you choose to draw on will affect the overall appearance of your drawing. In this *Portrait of Alice Linell*, by Christine Fitzmaurice, *right*, the artist chose a textured drawing paper over which she applied the pencil pigment lightly. The result is a very smooth finish broken up by the paper surface to create a pretty, stippled effect that enhances the gentleness of the portrait.

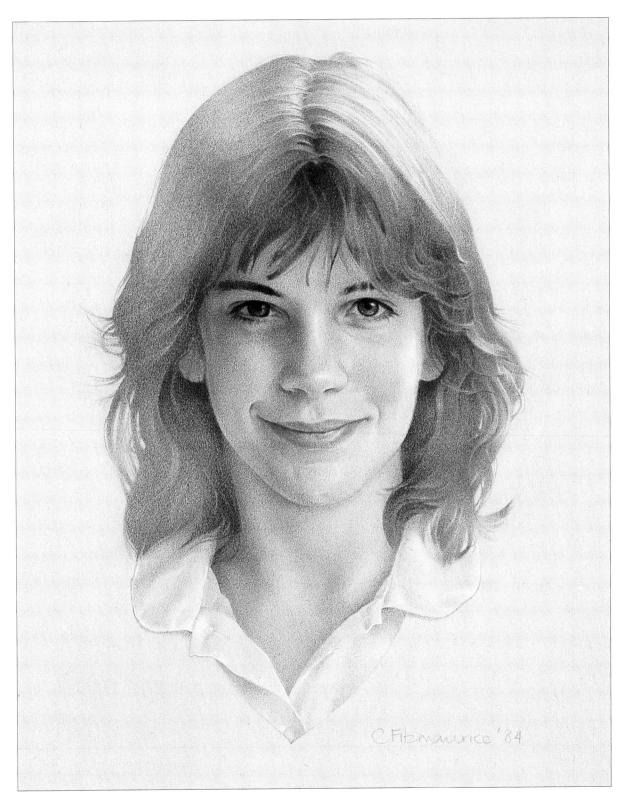

Every artist has a particular style that can be analyzed on close study of his or her work. In this promotion of fresh cream, *right*, the artist, Simon Thompson, used hatching and cross-hatching throughout his work to create colour and texture. The flaky, crisp texture of the pastry and the papery quality of the cases are made even more convincing by his deft use of hatching; the purple shadows of the cakes are given added resonance by the fact that they are produced by hatching red and pink over blue rather than by laying down pure purple pigment.

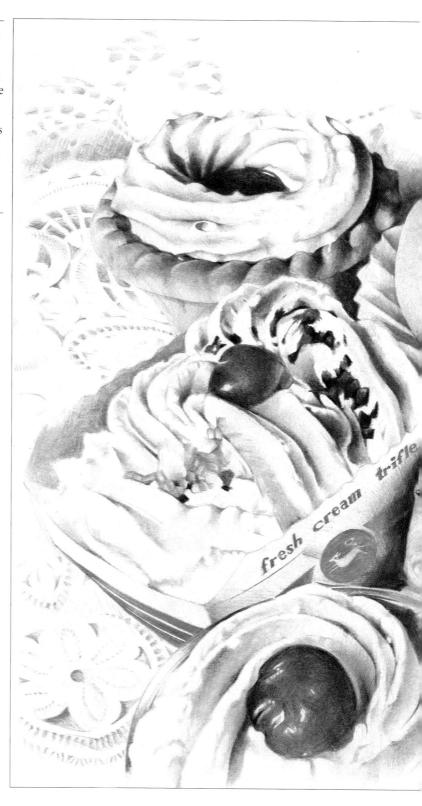

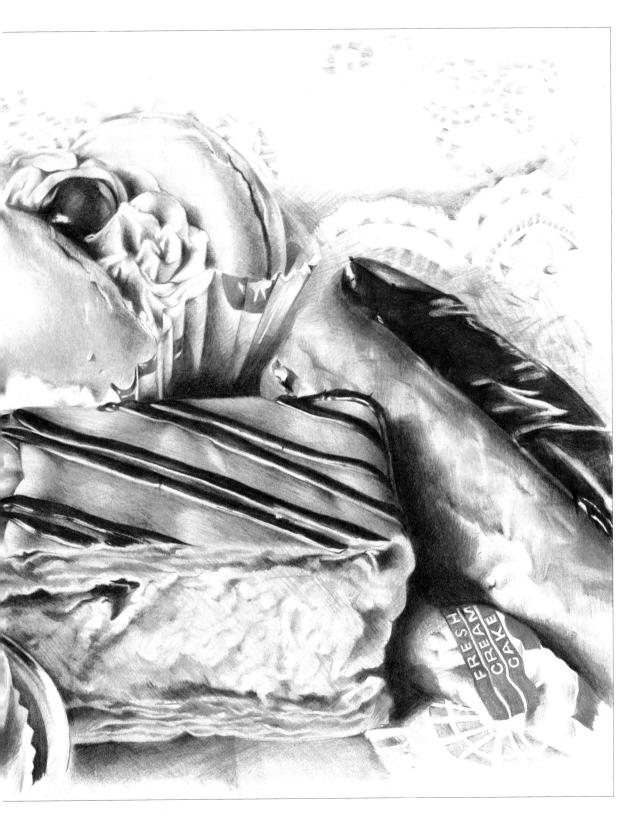

One of the most difficult problems you may face is how to transform three dimensions onto a flat, twodimensional sheet of paper and still produce an apparently three-dimensional image. To do this you have to understand three important elements - form, shape and colour. However, you are also at liberty to interpret or exaggerate reality in such a way as to substantiate the truth - by making objects longer or shorter, lighter or darker, or by introducing unexpected colours, for example. Only by appreciating what your eve perceives as reality and knowing what actually exists can you explore and create a realistic image. The extent to which these elements are assimilated and the style in which they are conveyed creates the character of the final work, whereas the materials used in producing the work and the emotive way in which they are handled convey the soul of the physical work. All combine to reflect the personality of the artistic interpretation. The inherent beauty and strength of colour drawing and its repertoire for expression can be developed into a unique language - every picture does indeed tell a story. The following chapters investigate the potential and applications of coloured pencils in terms of a new-found flexibility in an ever-expanding art that is widely and easily available to all.

TYPES OF DRAWING

To discover a coloured pencil technique and an application which suits you, it helps to study the style and technique of various types of drawing. A good way to begin analyzing other artists' work, to question their use of colour, shape and form and their standpoint, is to gather together a number of examples of coloured pencil drawings culled from a wide range of periodicals. Cover vastly different subject areas, from cookery to fashion, food, cars and architecture, and perhaps display your 'tear sheet' examples on a pin-board - it is often easier to live with such reference material for a while rather than trying to take it all in at once. You will probably find very distinct patterns in the way artists have handled their subjects. They will be a reflection of their personal approach and their reaction to the medium they are using. Some artists may work on a small close-knit drawing in very precise areas of colour, using complex methods to build up tones and produce a tight rendering. Others may develop a much more fluid, loose, linear style which may be acceptable in some subject areas and adequately satisfy the purpose of the drawing.

You could also analyze finished words in terms of their use of colour – is it provocative? does it question accepted principles? how has it been handled – has it been treated with greater importance than the subject matter, laid in complex and laborious ways, or has it been treated as a matter of secondary importance? perhaps the artist has distilled the reality into a collection of simple flat tones?

In thinking through the reactions of other artists you yourself will reach a solid starting point for your own interpretations. To put these ideas into practice it may be a useful exercise to take a simple still life subject and look at it in different ways. Consider it as a piece of coloured line work, bold and sketchy, or a compilation of flat tones; treat it as a black and white object; or with natural colour: draw it in a colour other than its natural one. Try seeing the colour of the object as positive, reducing the background to a secondary role, then reverse the colour bias and see your object in the negative. If you then combine these exercises with the vast array of techniques that apply to the use of coloured pencils, you will be closer to understanding which methods suit you and your preferred subject matter. You may choose to work in a relatively tight area, such as architectural drawing, where coloured pencils offer a very controllable medium. At the other end of the scale you may prefer landscape drawing, where you will probably want to experiment with the fluid subtlety of water-soluble pencils which provide the muted, blended colours seen in nature itself.

In contrast to the preceding drawing the artist in this case, Ian Sidaway, uses much looser, freer strokes in his works. In this image of conifers in parkland, *right*, the loose thick strokes used on the trees are ideal for conveying the way the needle-like leaves grow. Similarly, the free handling of the grass in the foreground gives an impression of the texture of a grassy expanse

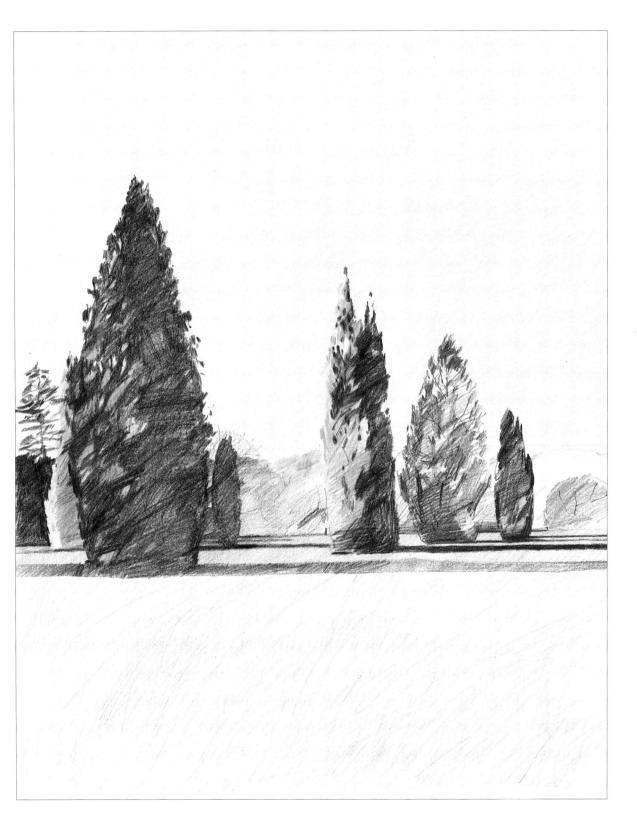

CHAPTER TWO

MATERIALS

A work of art may be judged and appreciated on many levels – its qualities are numerous but the quality of the technique and the style of the artist, while being of foremost importance, are nonetheless tempered by the quality of the materials used. It is the physical ingredients in a work of art which add life and beauty to the image and it is these 'ingredients' which can easily determine both your end result and the way in which you work.

The materials you need for coloured pencil drawing are not many, but they need to be of a high quality if your drawing is to last. You will need sketchbooks, a good range of papers, a selection of pencils of different lead qualities, erasers, sharpeners and, for special effects, burnishing implements.

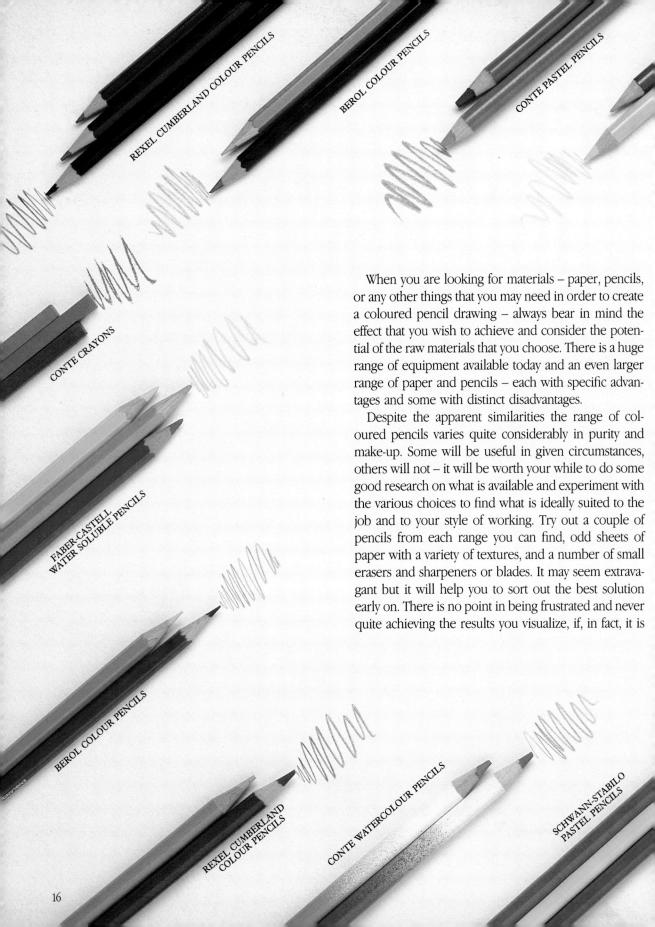

CONTE WHITE DRAWING PENCI TE PIERE NOR DRAWING PENCH all down to the simple problem that you are not using the right materials in the right way on a particular job. **PENCILS** Coloured pencils come in many varieties, all made in roughly the same way, but their qualities vary from manufacturer to manufacturer and from range to range - there are no international standards guaranteeing the end results, and indeed the way in which the pencil is used will in fact determine the end results! Close inspection will reveal that coloured pencils come in slightly different lengths: some will have circular cas-BEROL CHINA MARKER ings, others will be faceted; some will be cased in harder woods than others; some will have very pure pigmented leads and others less so. All these attributes affect the way in which the pencil will handle. Very fine, compacted leads are fairly hard and are best suited to a hard drawing surface which offers a fine tooth for the pigment uptake. Softer, crumbly leads are best on softer, textured surfaces where they deposit pigment easily without tearing the paper. The quality of the lead will also determine how you sharpen it - hard leads will CARAN D'ROHE COLOUR PERCH!

tured in colour sets of 40 pigments and many dry coloured pencil ranges now extend to 70 colours or more. Some of these will be soluble with other blending mediums but their success will vary according to their 'lead' composition. Pencil leads themselves also vary in size – thicker leads are useful when working on a large scale, whereas thin leads may prove to be too laborious to use. The width of the lead also affects its sharpening capabilities.

However you choose your pencils it is a good idea to buy a few of each range available and practise with them for a while. You will most probably want to use more than one range and may well end up buying a couple of small sets of dry colours and a small set of water-soluble pencils. Sets are often the best point at which to start because they offer a predetermined colour range and capability and can be easily expanded in areas where you find the need for a greater range of pigments. Most manufacturers sell sets in numbers of 6, 12, 18, 24 and so on. A range of 12 or 18 is the ideal point at which to start because it will force you to experiment with colour mixing rather than relying on pure, manufactured pigments.

Coloured pencils

Each range of coloured pencils manufactured has its own characteristics – some have soft leads, some hard; some produce smooth lines, some crumbly lines. All, however, have their own advantages. But the results you achieve will not depend ultimately on the type or quality of your materials, but on your ability to control and use them. The selection here was used by the artists in their demonstrations for this book. It is worth investigating the

potential of several ranges of coloured pencils as by comparing their qualities you can work out which will suit your style best.

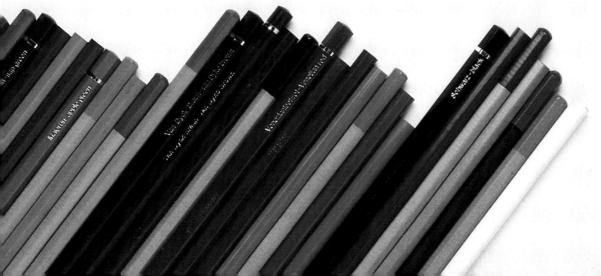

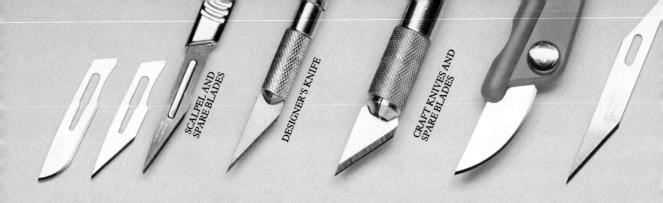

FIXATIVES

Many pencil pigments require fixing once they are in place. Generally the soft coloured pencils are the most prone to smudging, or leave an excess of pigment on the paper surface. However, it is wise to fix all drawings to assure a reasonable durability.

Fixatives are, in effect, a lacquer. They can be bought ready to use in spray cans or bottles which are sprayed through a mouth diffuser, (or you can make your own). Aerosols are easy to use and carry full instructions on their cans – simply point and press the nozzle. Mouth diffusers take a little more practice. They are in their simplest form a right-angled metal tube, at the bend of which is a hole into which you blow. The base is placed in the bottle of fixative, and you then blow through the hole. The liquid travels up the pipe to the hole through capillary action and is then suddenly thrust down the

length of the pipe at great speed through a nozzle, causing an overall spray effect. With practice, this is as good as an aerosol, but at first it can lead to blots and an uneven spray. It does have the advantage of not giving off such strong fumes as the aerosols, however.

As a last resort any other form of lacquer, including conventional hairspray, can be used, but do investigate such alternatives. Manufactured artist's fixative will leave almost no surface appearance whereas many applied lacquers leave a discernible gloss. Some papers accept the heavier lacquers and some just leave a tacky glaze. As with all materials, do experiment before applying it to a finished work. It is always best to select the right materials through practice – not on a finished piece. There is nothing worse than discovering after hours of labour that the wrong materials have been used.

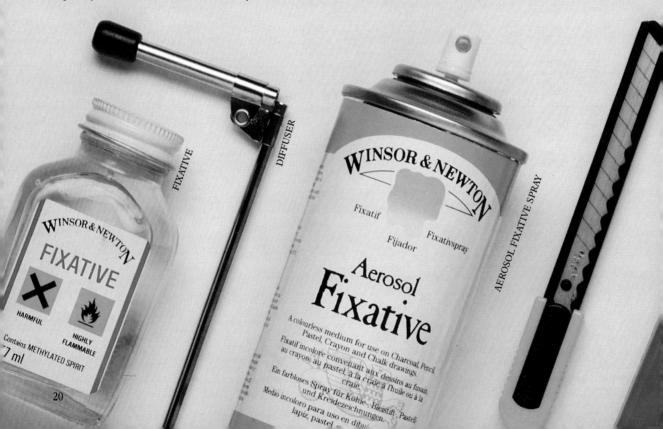

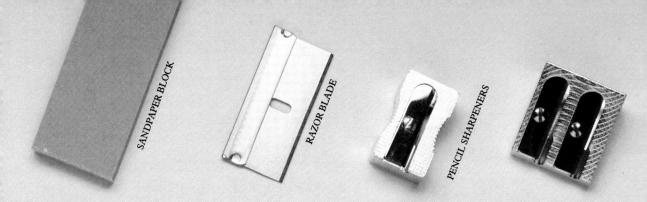

SHARPENERS

The way in which you sharpen your pencils and the implement that you use to do so will determine the type and scope of pencil marks that you will be able to create. The variety of sharpening tools available through most art shops offers you every permutation for forging your leads into the shapes that you wish. They range from simple pencil sharpeners to larger desk-mounted varieties, and even electric versions. These fixed-blade sharpeners all create conical, smooth-pointed leads, but offer no flexibility in the shape of the lead and, ultimately, the line it creates. Very soft, wood-cased pencils tend to unwrap too fast with these sharpeners and you will find that crumbly leads will be exposed too much.

Soft leads need careful handling and individual attention in sharpening – with these one of a number of knife blades will offer you greater control. Try using a scalpel

or a designer's knife with a fairly short blade. You could also try out a craft knife – those with extendable calibrated blades are the best. These may be snapped off once blunt and are cheap to replace. Large knives may prove difficult to handle; many have permanent blades which, although good, will blunt more readily when constantly used on wood. They may, however, suit your purpose. It is really a question of finding a knife that you can handle with ease because you will need to be precise and delicate to achieve fine results.

Once a point has been created you may want to reshape the lead and at the same time avoid removing more wood. To do this you can use either a sanding pad, which can be bought or made or, alternatively, a razor blade. Sanding pads consist of layers of sandpaper surrounding a wooden base. If you run the point or side of your lead across the texture this will sand it down to

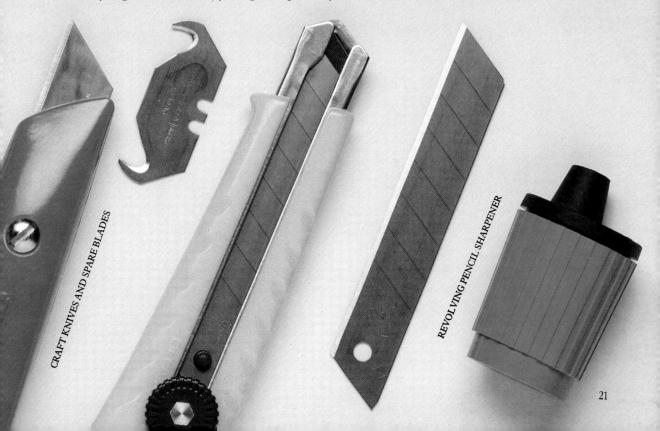

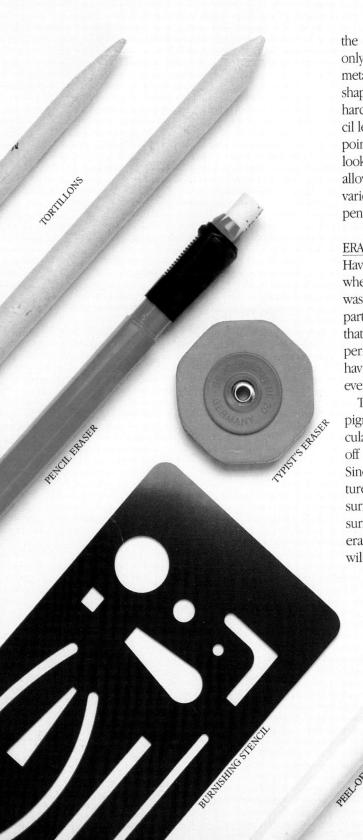

the desired effect. Razor blades with one cutting edge only can be used and they can be inserted into a small metal-holding strip for ease of use. They are ideal for shaping leads but tend to bend and snap if used on hardwood so treat them with caution. Sharpening pencil leads will take some practice – to achieve the desired points and edges the first time round is not as easy as it looks, but patience with a knife will reap dividends in allowing you a greatly extended vocabulary of line and a variety which is simply not possible using a simple pencil sharpener alone.

ERASERS

Having applied pigment there will always be occasions when you need to remove some of it either because it was applied in error or because you want to create a particular surface effect. There are many types of erasers that you may use for this purpose and after experimenting with one or two you will probably find that having a selection on hand will be the only answer to all eventualities.

The main aim in using an eraser must be to take off pigment without disturbing the drawing surface, particularly if it is soft. Many years ago bread was used to take off colour and it did little, if any, damage to the paper. Since then soft and hard erasers have been manufactured for specific use, but they cannot be used on all surfaces. Generally, hard erasers work best on hard surfaces and soft erasers on soft surfaces. Using a soft eraser on a hard surface will not offer enough key and will smudge the pigment, whereas too hard an eraser

S. Offipe all the

SHOIL FRANK

used on a soft paper will simply tear the paper.

Erasers come in many shapes and sizes. Traditional 'India Rubbers' are good for general use but beware of some of the other coloured varieties because they tend to leave their own pigmentation behind on your paper while removing the offending marks! The newer varieties of plastic-based erasers have soft and hard ends and offer a tighter, more solid substance to control. Plastic erasers are very useful where precise details need removing or where space is very tight because they maintain their edge and can be cut accurately with a blade to any useful shape. Gum erasers, such as Artgum erasers are built up from excess quantities of gum. They are very malleable and offer a good soft eraser for large areas or for creating smudged or blended effects of colour over wide expanses. Similar to gum erasers are kneadable erasers (or putty rubbers). which can be bought from art shops. They are extremely soft and can be pressed in the hand into almost any shape. They are good all-over surface erasers or blenders but it is almost impossible to be precise with them. Some soft erasers are now available in a paper casing, like a pencil, which is removed as the point wears down. These can be very useful because they are both precise and can be cut down as soon as the rubber becomes contaminated with pencil pigment.

Because of the waxy nature of coloured pencil pigments it is important to keep whatever eraser you use clean – it is easy to transfer unwanted colours on a dirty eraser onto a drawing. Should it become too grubby wash the eraser in warm soapy water. Do not, however, use it again until it has dried thoroughly.

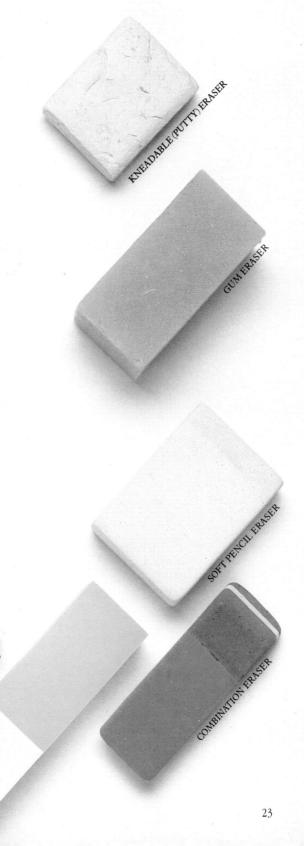

FARRANO ARTISTS PAREN

BLOXWORTH SPRING TOELL

PAPER

Just as important a decision as the type of pencil, sharpener and eraser you use is your choice of paper. Paper comes in so many different compositions, surfaces and finishes that your final choice will probably be governed by the selection available to you rather than a lack of the paper which suits your needs.

Paper has a natural texture peculiar to its fibrous composition. A particular surface will result depending on the nature of the raw material and how that material lies when the paper pulp settles during production. This roughness is the tooth or texture of the paper and it is this texture which takes pigment from the pencil as the pencil point rubs against it. Analyzing the portion of coloured pencil tone will show you that the uptake of pigment is directly proportional and in complete sympathy with the paper's surface.

Most 'off-the-shelf' papers are machine-manufactured, although there are still many companies that produce beautiful handmade drawing papers, using processes that have remained much the same for hundreds of years. The real attraction of handmade, or mouldmade, paper is its very individual character; in fact each sheet

SAUTHER TO LOUR HUCCH

Dadie Antigerold day and

THE WELL WATERCOLOUR PAD

LANGTON WATERCOL

WHATWAN ACID FREE 1880 FAC

has a personality and is entirely different from the next. Handmade papers have a level of texture that is never found in the machine-made versions.

Traditionally the raw material for paper has been old cotton or linen rags, although cotton, linen, jute, ramie and esparto fibres still produce the purest paper pulp. Rag papers tend to be produced for specialist markets now, because the raw materials are more expensive than the plant pulp used for mass-market production. The sheets of paper are sold individually or made up into blocks of drawing paper, trimmed and bound with a retaining glue-strip edge. Handmade papers such as the popular Fabriano ranges have been in production since 1260 and are still favourites with pencil artists today. These drawing papers, available through most good suppliers, are all-rag, acid-free papers, which have been air dried and sized with gelatine. They are available in Rough, Medium and Smooth surfaces and, together with other makes such as Arches, are some of the best papers you can buy.

Drawing papers of this sort, whether hand- or machine-made, are classified as Rough, Cold Pressed or Hot Pressed. A Rough surface describes the texture of

MOVIIM REPROBLEM 1. An 1492 ARCHES WATERCOLOUR AND TEMPERA PARTER

paper which is allowed to dry without any smoothing or pressing, 'Cold Pressed', or Not, refers to the way in which the sheets are laid on top of each other without felts and consequently become slightly compressed, creating a smoother texture. 'Hot Pressed' papers are those which have been 'finished', or passed through heated rollers in order to achieve a smooth surface.

Each paper mill has its own techniques and peculiarities. The beauty of any handmade product is that no two examples will be exactly alike, despite the deft skills of the papermakers. Try out a range of handmade papers to see the different effects you can achieve on their surfaces with a variety of coloured pencils. Some papers will be softer than others, some will have random textures, some will be more marked. The range of Smooth (Hot Pressed), Rough and Cold Pressed surfaces from different makers offers you a variety which can add a dimension to your drawing.

Manufactured papers are not as highly textured as handmade papers are and therefore offer a different scale of possible effects, many of which could not be achieved on handmade or mouldmade surfaces. Very regular fine-grained papers, such as cartridge papers,

SPIRAL BOUND SKETCH PADS

DERWENT

A4 PAD gr sheets of quality
unite cartridge, 13083 in.
united to a second se 新茶品品品品品品品品

SKETCHPAD

Containing 80 sheets
Containing paper

are ideal drawing surfaces particularly when stretched. Some highly coated papers like CS10, or Bristol boards, may also produce interesting results when used with hard leads. Coloured papers such as the Canson Mi-Teintes, which is a light-resistant, coloured-in-the-pulp drawing paper, can create beautiful effects when used with translucent coloured pencils because they will alter entirely the range of colours produced. Other coloured textured papers, such as Ingres, or even creamy papers like vellum, will add a new dimension to colour creation as well as texture.

Consider, as well, using some of the vast ranges of machine-textured papers currently available, with effects like linen graining, elephant hide, or leather. These surfaces need not prove to be too obtrusive and, if they are used for the right purpose, will create stunning results. Think, too, about how you want to use your papers and whether you should buy pads of paper or loose sheets.

There are no real guidelines except that good papers are a joy to work with, they do not wrinkle when stretched, or scuff when rubbed under normal circumstances. They take the coloured pencil pigment beautifully and are well worth the investment.

HARDBACK SKETCHBOOKS

POCKET SKETCHBOOK

WATERPROOF CHBOOK POCKET SKETCHBOOK

77

STRETCHING

The structure of papers differs enormously: some are tightly-packed fibrous compositions whereas others are loose; in some the fibres run virtually vertically and in others they may form a criss-cross weave pattern; some are thick and some thin. When using a quantity of solution on some papers the liquid will be accepted into the paper surface without altering the paper's structure; on others, saturation with water or a blending agent will result in the dry fibres soaking up the solution and expanding, in effect causing the paper to wrinkle. This creates a very difficult, uneven surface on which to work, and may also result in the paper disintegrating.

Heavy-purpose watercolour papers are constructed in such a way as to avoid wrinkling when wet, as are many harder papers with special non-porous surfaces. But if you like drawing with water-soluble pencils on a medium-weight, medium-texture drawing paper or paper of similar quality, you will need to treat the drawing surface. There is a simple method of paper preparation which will produce a very good surface on which to work and avoid some of the problems mentioned. This method is known as stretching the paper.

Stretching paper involves keeping the paper taut so that any medium applied to the surface will not cause the fibres to expand. It is quite simply achieved. First, select your paper. All paper, depending on how it is manufactured, will have a right and a wrong side. With a heavy texture it is easy to tell, but with a light drawing paper it is not always so obvious. Try holding your sheet of paper in front of a window or direct light source and bend it slightly. On the curvature you will notice a texture which is slightly raised on one side – this is the top face of the paper on which you will draw. The other side will appear flatter and more regular in its composition – this is the underside of the paper. However

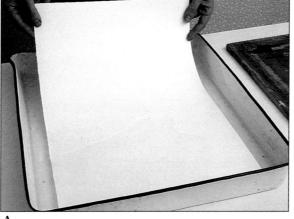

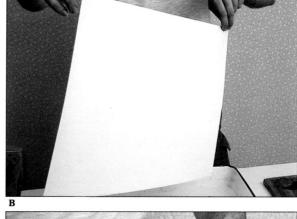

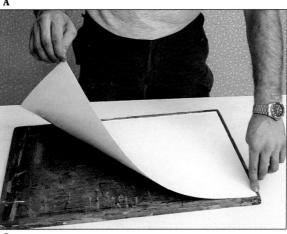

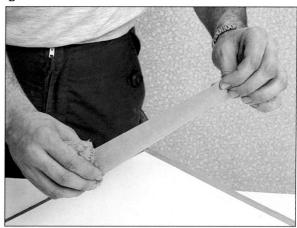

D

smooth a paper is, unless it is coated with a special surface (which drawing papers seldom are) it will have greater texture on its drawing surface and in effect a greater tooth for taking up the coloured pencil pigment. But when using a smooth, light, cartridge paper, the difference between the two sides will be minimal, so your pigment application will not be disastrously affected should you get it wrong.

Having selected your paper, float the whole sheet flat in a bath of cold water. Do not leave it submerged for too long – 10 to 20 minutes should suffice. If it is a particularly soft paper, oversoaking may result in its disintegration, whereas a harder paper will require more time to take up the water. It may be useful to get into a routine and always soak the paper face-up or face-down – it makes no difference to the paper, but you will find it infuriating if you do forget which side is which, and handling soaked papers is not always easy.

After the paper has soaked, lift it gently from the water by two corners. Avoid touching the main drawing face of the sheet, because it is now at its most delicate and will easily scuff or mark. Holding the two corners, press the upper edge onto the upper edge of your drawing board. Make sure you use a solid board surface that is smooth and clean. Hardboards and other pliable surfaces will not do, particularly if used with large sheets of paper, because they tend to warp both from the moisture content of the paper and as a result of the paper's tension as it dries out.

Having set the top edge of the paper in position, carefully lower the sheet, making sure that pockets of air do not get trapped under it. If you hold the paper to its fullest extent, this should not occur; it will, however, if you allow the paper to flop or sag. If, after you have laid the paper, air still appears to be trapped, gently lift each corner and lower it again.

Stretching paper

When stretching paper, find the right side of the surface by holding it up to the light - if there is a watermark it should read correctly on the right side. Lay the paper right side up in a tray of clean water, A, and, keeping it flat, soak it for 10 to 20 minutes. **B** Lift the paper out by one edge and shake it gently to get rid of any excess water. C Lay the wet paper right side up on the drawing board, making sure that you don't trap any air under the paper, and that the paper is completely flat. D Cut lengths of gummed paper and wet them with a sponge. E Stick each side of the paper to a drawing board with gummed paper, and push drawing pins into each corner of the paper to secure it. Let the paper dry naturally away from any source of heat.

Once the paper is in place it can be secured using a strong, 2-5cm (1 inch), gummed brown paper tape (gumstrip). Cut a length of tape to the full length of each side of the sheet of paper, allowing a bit extra to overlap, and wrap it around the edge of the board. Then carefully moisten the tape and stick it along each edge, half to the paper, half to the board. Once the paper is stuck down it should be placed flat to dry out at room temperature. Do not place it at an angle until at least most

Once the paper is in place it can be secured using a of the water has evaporated, because if you do the top will dry faster than the bottom, which will either cause umstrip). Cut a length of tape to the full length of each the paper to become unattached, or worse, to tear.

The paper will take 12 hours or so to dry, so it is a good idea to prepare one or two surfaces at least a day in advance. Do not be tempted to speed up the drying process with a heater of any form, because this will destroy the paper's structure. It will cause uneven drying, false tensions within the surface which will soon

Preparing a gesso ground

When preparing a gesso ground, use a damp brush so that you do not get any air bubbles in the ground. Brush on one coat of ground and let it dry, *right*. Apply several coats, brushing each one on in the opposite direction to the previous coat, and allowing each layer to dry before applying the next one *below right*.

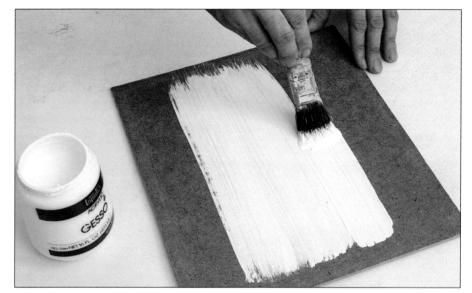

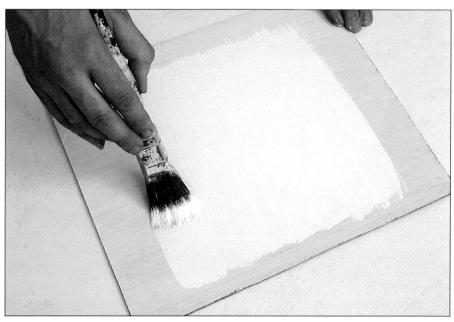

show once liquid is applied to it or, indeed, it is quite possible that the paper may not be able to accept a sudden contraction and will simply tear.

If you are left with any pools of water on the surface during the first few hours of drying they can be soaked up with tissue or a soft sponge – but under no circumstances rub the paper surface while it is damp because it will just destroy the texture and the paper structure, or tear it in half.

Once the paper is dry it will be fully taut and should not wrinkle when saturated with a liquid medium – if it does, then it has not been stretched fully. It will also be less inclined to buckle under heavy pencil pressure, such as one might use in burnished work. Stretched paper is a good drawing surface, the only disadvantage being that the artist has to plan in advance to use it, and has to be prepared to carry a drawing board to support it, if on location. For studio purposes it is ideal.

Gesso finishes

Above left and above are two methods of creating different finishes on the gesso. A natural sponge produces a stippled texture that provides a tooth for the pigment to catch on.

Smoothing gesso with a palette knife creates large untextured areas. Left, using very fine sandpaper you can rub away any unwanted texture in the dried gesso and obtain a very smooth finish.

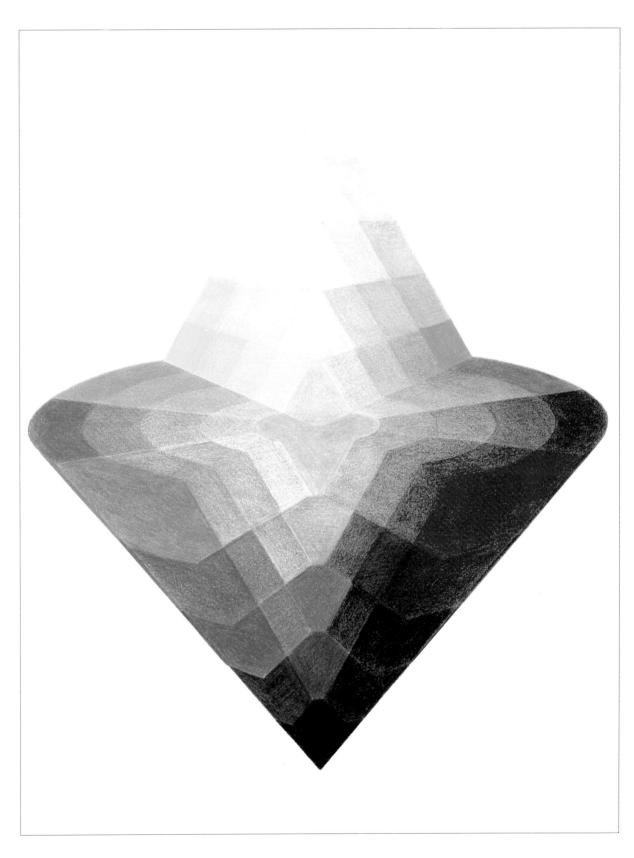

CHAPTER THREE

COLOUR AND COMPOSITION

The first stage of any drawn communication is a line, but to increase its potency we introduce two more elements — tone and colour. In essence, colour is light — light refracted and light absorbed. Without light we see nothing. With it we see an estimated six million colours. Exploring and depicting those colours will not only expand our understanding of reality but will also train our minds to interpret what is beyond the immediately obvious. Even so, the interpretation of colour is personal as well as scientific — no two people see the same colour in the same way. Artists use these two interpretations to depict colour on two levels — the representational level (in the description of feeling).

It is helpful when observing and using colour to be aware of some basic colour theory. However, many ideas on colour are hotly disputed and we are working in largely uncharted areas, where the experience and interpretation of colour is still a voyage of experimentation and discovery.

The double cone-shaped structure, *left*, has proved to be one of the most useful diagrams that illustrates the tonal range in colours. Running through the central axis is the grey scale, from white at the top to black at the bottom. Around the perimeter of the cone are the pure or saturated colours which gradate towards the centre in terms of lightness and darkness.

ADDITIVE AND SUBTRACTIVE COLOUR

White light is composed of colours and is not just an invisible void. These colours can be seen when we pass a beam of white light through a prism and produce a rainbow. It is possible to create white light using only three of these spectral colours – orange-red, green and blue-violet. But when two of these colours are projected over each other, only certain colours are created: blue-violet and green combine to create cyan blue; green and orange-red combine to create yellow; and orange-red and blue-violet combine to create magenta. This is called additive colour mixing and the three colours produced by this overlapping are known as secondary colours.

Colours produced by the combination of physical substances such as paint and pencil pigment are largely the result not of light itself but of the power of the colour pigment to absorb light rather than refract it. The principles that apply to light are therefore not necessarily parallelled when applied to pigments. The mixing of substances like pigments is known as subtractive colour mixing. The three subtractive primary colours are magenta red, cyan blue and chrome yellow. Just as in light, these primary colours cannot be imitated by mixing a set of colours. But when these three primary pigments are mixed, one with another, the following results: yellow and magenta create red-orange; magenta

and cyan mix to create blue-violet; and yellow and cyan blend to create green. All three combine to make black. Black is therefore not a lack of colours.

RECREATING PERCEIVED COLOUR

It is simplistic to say that all colours are the result of such combinations but these basic illustrations of the primary additive and subtractive colours and their intermixing to create black and white serve to remind us that what we see as a particular colour is very probably a collection of colours. The human eye is not capable of distinguishing the myriad colour values in a given area, so it reads a collection of colours as a whole and generalizes them. Its perception of colour is also dependent on the medium in which the colour is embodied. For example, the incandescence of a tropical fish seen in water at night will be greatly reduced if the same fish is seen out of water in daylight. Similarly the colours of objects in the bright clear light of a tropical country will be greatly subdued if transported into the polluted heavy atmosphere of an urban environment.

The manipulation of colour is the domain of the artist; you may subdue or exaggerate, transpose and control the exact nature of the colour image you wish to convey. Only through practice and experimentation with pigments will you learn how to recreate what you perceive. You can, for example, produce a colour with

Coloured light and coloured pigment

The diagrams here show the different mixing properties of light, right, and pigment, far right. The three primary colours of light – green, red and blue – are mixed to produce secondary colours – magenta, yellow and cyan. This is additive mixing. The three primary colours of pigment – yellow, cyan and magenta – mix to create red, blue and green. The mixing of coloured substances that absorb light is known as subtractive colour mixing.

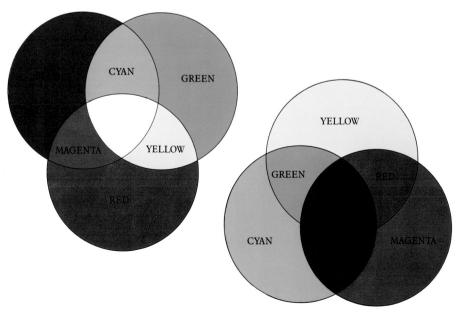

The spectrum

The pigmented representation of the light spectrum, left, illustrates the colours that result when a beam of white light is split into its component parts.

COMPOSITION

lightness or darkness.

Creating a colour composition is as fundamental to a drawing as is your style. It is wise to begin all coloured pencil works by making 'thumbnail' sketches. These may be very small and need only be simple line drawings, but they will help you to view the subject from various angles. They are worth their weight in gold as reference notes for the shapes and colours on location and will refresh your memory when you work them up later. By drawing small sketches you can analyze and compare the composition of reality and the composition that you want to create, before committing too much to paper - in other words, they allow you to reorganize reality.

low intensity, or saturation, by rubbing a pencil lightly

over paper, depositing small amounts of pigment. But if

you press down very hard a large quantity of pigment is

deposited on the surface, creating a high saturation

level, or intensity. It is also possible to modify pigment colour through the addition of grev. If you take a grev scale – the graded shades of black from solid black through to white - and mix these tones with hues, you will achieve a large range of lighter or darker colours. The resulting colours are simply described in terms of

At this point it is important to consider where to

Colour wheels Colour wheels, below, are

simply interpretations of the linear light spectrum, joined end to end. They show quite clearly the relationships between the primary colours and their opposite, or complementary colours, and their adjacent colours. The wheel on the left shows the six main spectral colours and the wheel on the right indicates their intermediate hues.

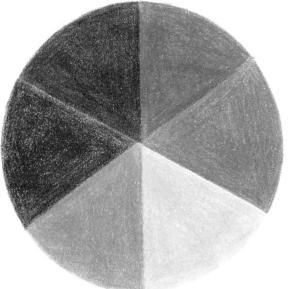

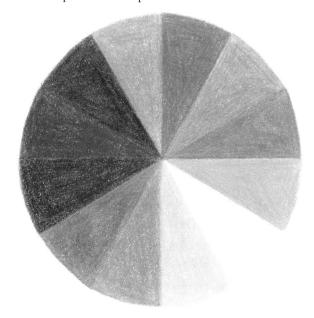

break the composition, how much foreground you should allow, and whether a tall portrait shape or horizontal landscape format would best suit the subject matter of your image. You can quickly decide the format by drawing a frame around the area to see how the subject would appear in the chosen shape. Alternatively, it is often useful to carry a pair of L-shaped cardboard elbows with which to frame your intended subject and isolate it from the surrounding shapes and colours. By adjusting the frame to create different shapes you can then study a number of permutations before you reach your final decision.

Once the internal structure and parameters of the work have been established you must consider colour. Because working with coloured pencils can be a relatively slow exercise, it is important first to establish a plan of action on a small area. You can do this by mixing colours alongside the preliminary sketch and adding them to the line drawing, or thumbnail sketch, one by one. Gradually a miniature picture will evolve and, in performing this task, you will constantly be assessing the colour and form of the final image before it is set down. If, for example, a shape requires pulling forward then you can adapt the composition to do this; likewise if a colour needs to be moved to create a focal point within the picture, you can move it.

Any colour we see is related to our perceptions of scale, which are based on our own physical proportions. When portraying colours you will find that what might in its natural context be seen as a colour with a huge form or shape or presence, will look insignificant within the confines of a small image area. You will therefore have to increase the shade or saturation of the colour in order to make it look 'real' in your drawing. The reverse is also true when drawing a small picture of a brightly coloured small object. It will be an exaggerated view of the subject, out of all proportion to reality, although it may indeed be 'real' in every sense.

Advancing and receding colour

A colour's power and its visual dominance are often a direct result of its surrounding colour and what the human eye relates it to – if you like, its colour

context. It is also affected by its volume or area. The panel, *right*, illustrates five pairs of colours in reversed positions to show how area and context affect the feeling of a colour, making it advance or recede.

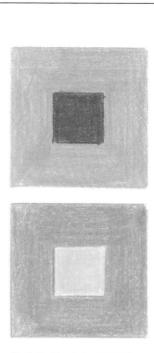

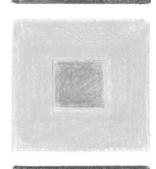

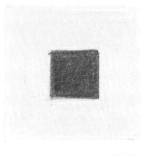

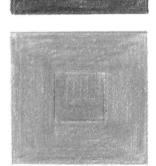

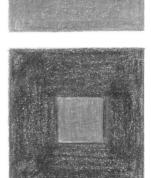

Composing an image

Thumbnail sketches are an essential starting point for any decisions on composition, from the points of view of both form and colour. Explore the possible variations by altering the amounts of background or foreground included, and by placing the focal point of the work at the left and right side of the composition. In the

example, *right*, the verticality of the vase of flowers is balanced by the horizontal expanse of the window. In the image *below* the artist decides to use the angles of the corner of the room and the table in contrast to the cylindrical form of the vase.

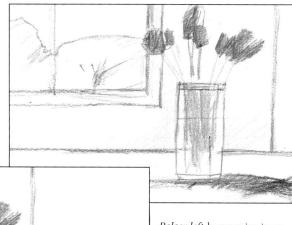

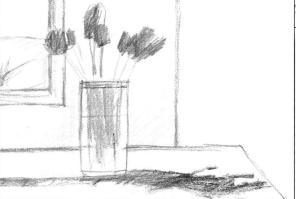

Below left, by cropping in on the sides and emphasizing the vertical feeling of the image, the vase of tulips is made to dominate the composition. By taking a viewpoint farther back and bringing in the edge of the table, below, the centrally placed vase is integrated more fully into its environment and the composition.

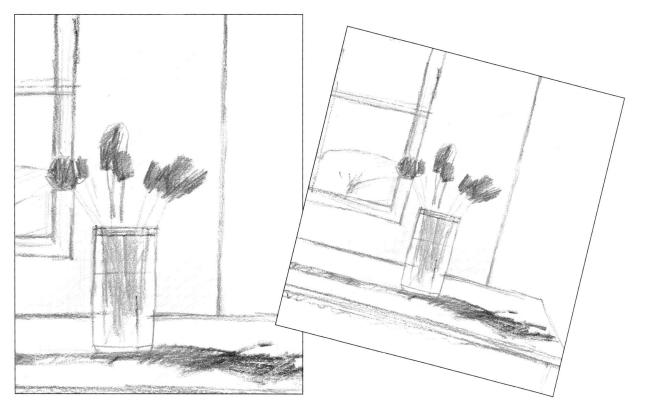

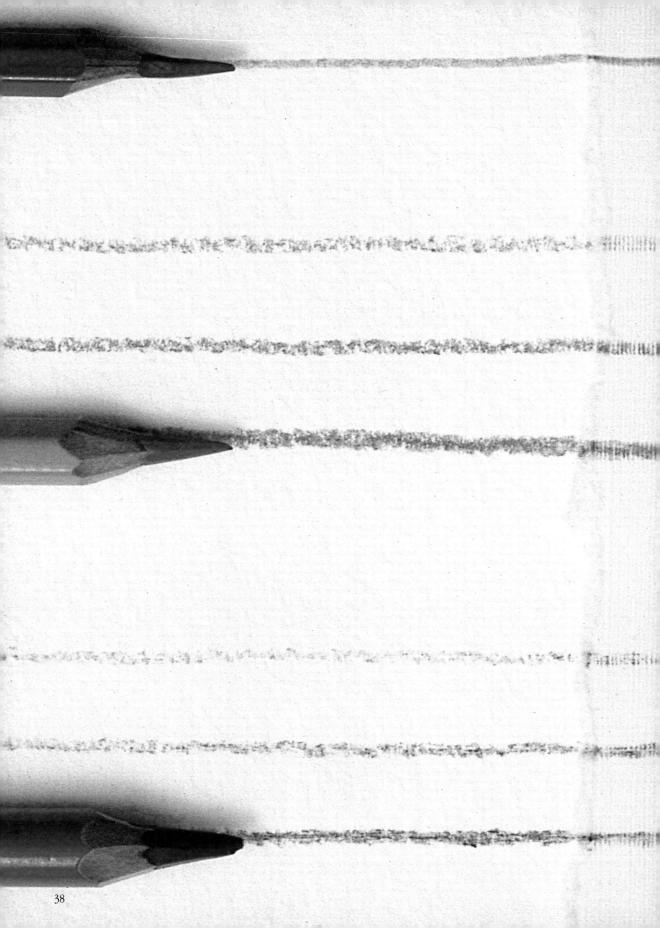

CHAPTER FOUR

STROKES

A drawn line or stroke may be the most elementary statement, but it is nonetheless one of the most important and emotive marks in artistic expression. It is quite useful to practise making several strokes to investigate their potential. This is not stating the obvious – far from it. It is an exercise in working a pencil in order for you to be able to handle it, understand it, and feel through it, to create your desired effect. It is the rapport between your hand, your pencil and the paper which will enable you to create a physical impression of your mental image. The degree of control that you have over this facility will, in the end, affect the degree of versatility and the range of effect you will achieve – if you like, the palette of your abilities.

CHOOSING YOUR MATERIALS

Before you start to make a stroke it is important to consider what type of effect you require, because this will determine your choice of materials. For instance, if you compare a number of pencils, you will see that the leads have different qualities - hard or soft, smooth or crumbly. These qualities will be heightened depending on the type of paper surface you use - a hard lead will not flow easily over a Rough or Cold Pressed surface, whereas a soft lead will; a very soft lead, on the other hand, tends to crumble if drawn over a paper which is very heavily textured. It is important to experiment with a variety of drawing surfaces such as watercolour paper, machine-textured paper and gesso boards to discover your favourite materials and the right pencils for them. Try buying a variety of textured papers in sheet form and draw a simple area of line and tone over each, using the same pencil throughout. This will soon illustrate the influence of the surface on the range of effects that you can achieve.

SHARPENING YOUR PENCIL

Having decided what type of pencil you want to use, it is important to ascertain its 'crumble factor'. This will dictate, or at least help you to decide, how to sharpen the pencil, which is of paramount importance in determining the type of line you will achieve. It is easy to maintain a fairly sharp point with a hard lead, whereas many softer leads tend to crumble if too much lead is exposed from the wood, or if the sharpener does not reduce the lead gradually. A standard pencil sharpener will produce a reasonably even, rounded point, but for other effects you should experiment with a craft knife, Stanley knife or scalpel. Try using various blades to sharpen your pencil until you find one with which you are comfortable, because you will need to be in total control of your cutting instrument in order to be able to

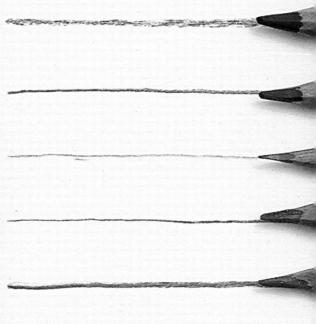

Strokes with different leads

The difference in the texture of pencil leads creates quite different lines, above. The topmost pencil has a pastel consistency and so produces a very smudgy, textured line. Similarly, the watercolour pencil at the bottom has a soft lead which makes a thick line. The pencil in the centre has a very hard lead, which creates a thin, consistent line.

different types of lines they produce. Sharp points will produce thin, purposeful, controllable strokes, whereas rounded points will make a fuzzy-edged, soft line, chisel-edged or faceted leads will give broad and soft, or scratchy, lines depending on how saturated the lead is with pigment.

It is also an interesting exercise to contrast how, cut a precise shape. By shaping the lead into two very when these various points produce a constant line, the flat surfaces with a knife, for example, you can pare the lines differ. With a sharp point the constancy of the line's point to a chisel shape which offers a large, flat area of texture will be greater than if you flatten the lead, when pigment to the paper surface; or by gently creating the movement of the pencil will be affected by the several smaller but equal flat faces you will form a bumps and grains of the paper's texture, and produce a faceted point which will produce fluctuating line widths. line with great variations in width, all within the same Having sharpened your pencils in different ways with stroke. Some pencil leads contain pigment particles each instrument, make a stroke on the paper to see the which can be scratchy; this characteristic may or may not

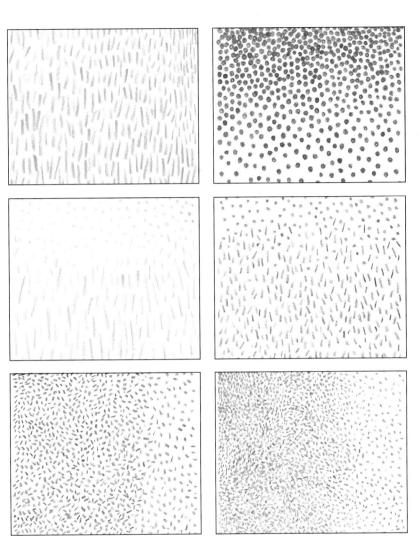

Strokes and texture

The blocks of marks, left, show how very simple strokes can produce a huge range of surface patterns and textures with their own shape and directional statements. Top far left, a regular, more or less vertical, pattern is produced with short lines of similar line length. Top, left, by twisting the point of the pencil on the paper, very even dots can be created which suggest tone, and by varying the density of their distribution it is possible to suggest lighter or darker colour. Centre far left, dots becoming short lines create a sense of movement and direction. Centre left, very short consistent lines produce a stippled, almost prickly, texture. Bottom, far left, very short lines applied in a random direction create a harsher texture than the dots do. Bottom left, by shortening strokes and increasing their density a sense of shadow can be produced.

appeal to you, but bear in mind that the greater the exposed surface of lead the higher the potential for unevenness in the application of colour.

DRAWN DOTS

Drawing dots is a good point at which to start in your investigation of strokes. Dots may be produced simply by banging the point of the pencil on the surface. Again, the leads will vary in their reaction to this treatment, providing a range of marks from precise pin-pricks to smudgy spots. By moving the pencil just a fraction when you are hitting the paper, small strokes will begin to form. The way in which these dot-strokes form will suggest a visual direction, as will their density. By placing dots closer together a heavier texture can be

created, aided by the solid appearance of the pigment. As the dots are moved farther apart the white space around the pigment becomes more apparent and the effect of the dot texture is diminished, or lightened.

Try creating movement and density within dot patterns in monochrome, and then apply the same technique to a number of combined colours. As you now know, colours are comprised of many parts of light combining to form different colours. The eye does not read a complex area of colours as a combination of pigments, but will assess the general overall tone of the colour and read it as one. Very interesting effects can be achieved when you actually create colour with pencils using the pointillist dot technique. The coloured pencil is ideal for this technique, where pigment is mixed on

the drawing surface only and where combinations of pure pigments are used to create colour. By juxtaposing a number of coloured dots it is possible to create a colour mood; this technique, albeit time-consuming, also offers the most intricate scope possible to mix pure pigments. Using the same technique, but with a slightly thicker lead, you will achieve a stippled effect which will be heavier and denser than the dotted colour. Dots may also be drawn more precisely as spots and can offer a very distinctive, almost pop-art, style to a piece of work while still being used to create colour.

DOTS BECOME LINES

Once dots grow into short lines, they inherit a natural direction - usually that in which they are drawn. When making dots you can maintain the pencil in an almost vertical position, but in creating lines the angle of the pencil will further enhance the descriptive potential of the simple line. Experiment by drawing a line, holding each differently sharpened pencil at various angles. With practice you will find a comfortable and controllable method of drawing strokes, but basically there are two ways - underhand and overhand. Holding a pencil overhand (ie. supported by the curve between your thumb and forefinger), you will be able to vary accurately the angle at which the lead hits the paper. This way, either the point or a face of the point may be used at varying degrees with very little movement in the hand. When you hold a pencil underhand (ie. with the whole pencil held under your hand, supported by your fingers and directed by your thumb), you will expose the greatest area of bare lead which will give broad emphatic lines. These are very useful when you are drawing in a sketch-like manner on a large scale or when handling large sweeping areas of tone. Long wide movements are easily performed with this grip.

THE NATURE OF LINES

There are a number of types of line which can be categorized by their form. Lines can be continual, that is of a hard, stable, consistent character and width; they can be pressured, in that they will relate directly to the pressure and movement applied to them, being thick or thin at various points; broken lines are created when the pressure on the pencil is lifted, or the texture of the

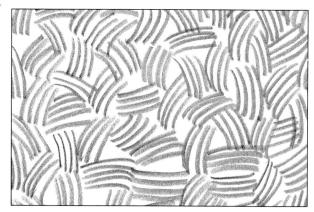

Strokes and texture

Textures – whether they are patterns or surface textures – can be built up using line. Above, top and centre, is a comparison of the qualities of groups of short lines in curved and straight formations. Both are similar and yet convey a

sense of very different pattern and movement. The increased spacing and length of lines adds to the feeling of speed and direction that they convey.

Paper surface and line quality

Left, the range of pigment uptake that occurs on a variety of paper with machine-textured surfaces is shown. Below, the width of pencil lines is affected by the way you hold the pencil – underhand, underhand and rolling the pencil, or overhand. Bottom, strokes drawn with various pressures differ in shape, width and tone.

surface dictates gaps in the line; composite lines comprise a number of fine lines combined to create a scratchy thick line.

Using these basic types you can proceed to create short lines. These carry their own particular message. Single short lines tend to be more controlled, tighter and less directional than longer lines are. But used en masse they create areas of dense tone and will establish both texture and direction in a subject. Short, straight, continual lines will, by their very nature, be rather static in appearance, but if groups of parallel short lines are

drawn they will indicate direction through their mass. By drawing small groups of parallel lines very interesting textures may be created, textures that either flow in a vague direction or that are highly stylized – like a basket-weave for example. Experiment with lines to create very complex hard or soft surfaces, such as a sheet of corrugated iron or a piece of knitting, and you will discover the vast capability of single lines and simple complications of linework to convey the texture and feel of a subject.

Strokes and movement

By applying strokes quickly in patches of exaggerated curves, longer strokes and shorter, slightly curved lines, a busy, turbulent pattern is created, *right*.

Long fluid lines which ripple slightly still convey movement and direction but the sense of speed is slow and the feeling one of tranquillity. By varying the density and thickness of the strokes you can emphasize dimension, *right*.

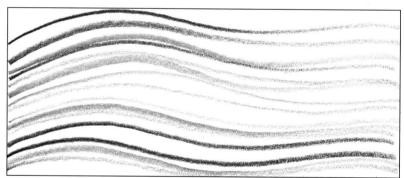

Strokes and form

The five illustrations, *right*, show the development of a colour, a shape and a three-dimensional form, using groups of short straight strokes. The shape develops as layer upon layer of linework build up the colour. In each layer the lines criss-cross in a similar pattern, leaving white space in areas of high colour and becoming denser in areas of shadow. In the final picture, *far right*, a flat background is drawn in the same style.

CURVED STROKES

Once the length of your line begins to grow it will develop a curvature. Because of the way in which the arm moves the body from left to right, or the other way, an arc-shaped gesture results. It is therefore quite natural that long lines should follow this sweeping curved movement. Because we tend to draw the finger and thumb inwards when moving the pencil from top to bottom, or alternatively pivot the hand when taking the pencil from left to right (or right to left), we again create a curved line. Curved lines are a natural development

from the creation of almost static dots or very short lines, and only through conscious effort and the use of rulers do we manage to keep lines straight.

Curved lines offer an added dimension within linework to create a sensation of movement and depth. They may be used in a static sense, depicting the shape of a curved surface by running in a similar direction; they may also be used individually or in small blocks, running in opposite directions to create a very complex texture. If the width of the line remains constant then a purely two-dimensional texture will be created, but if

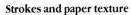

The texture of a line is affected by the texture of the paper on which it is drawn. Far left the lines are drawn on a smooth drawing paper which allows a dense solid line to be created. Centre, the paper has an embossed surface which catches the pigment in places but not in others, producing a series of vertical stripes. Left, the lines are drawn on a Rough, heavy watercolour paper, with a much more random texture.

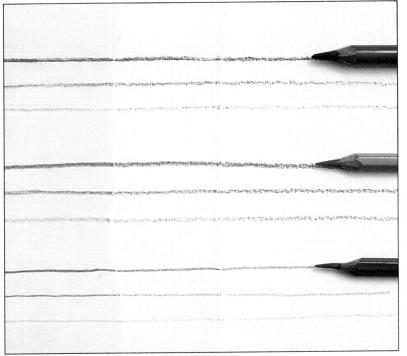

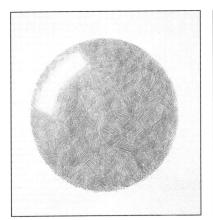

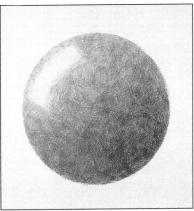

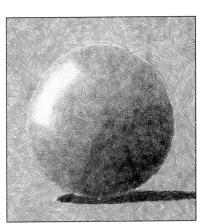

this width varies from thick to thin then the eye will not only be led around the subject but will also travel into and out of the image, adding a three-dimensional characteristic to simple linework.

Curved lines can also suggest movement or speed. Again, the fluctuating width of the line will substantiate the effect of moving from front to back or from left to right. Rapidly drawn, short curved lines will imply a quick movement, whereas long, gentle sweeping lines will insinuate slow smooth movement. Experiment in one colour to produce these various effects, then do the same exercise using a combination of colours and observe how colours such as red and vellow heighten the effect. Try also running curved lines in parallel, either as long strokes or as short controlled patches. Then compare them with curved lines flowing generally in a similiar direction, but drawn at random, and with curved lines drawn over each other in a completely ad hoc fashion. The complexity of statements you can create with curved lines is infinite.

LENGTHENING THE LINE

By increasing the length of a line you will develop a greater sense of direction in the image, be it an actual direction or just a visual one. The eye will read the density of lines and their flow. It will not be specific in vision, but will read the message as a whole, enabling you the artist to create a sense of shape. If these longer lines are 'pressured' and vary in width – for example, starting thick and decreasing in size - the eye will read along the line interpreting the message of distance. The heavier, thicker line will indicate foreground and as it narrows will give the impression of receding into the background. In this way you can depict natural perspectives in single lines or, in texture, through the build-up of these strokes. If you also introduce curvature into these strokes you will add yet another dimension to the texture which may be useful for describing shape or when interpreting textured surfaces such as fur or cloth.

When lines become particularly long they take on a scale of their own in relation to the subject and the size of the work. It is important to bear in mind the scale of your strokes compared with that of your image. If you use small, light lines on a drawing which is about 91cm (36in) square, the lines will blend into an overall

texture and colour; if the lines are made thicker and longer they will read as lines and colours and have an immediate meaning. Conversely, it is possible to read small, light lines in a work which is only 7.5cm (3in) square, whereas large lines may prove overpowering.

THE SPEED OF LINE

As well as being thick or thin, light or pressured, lines also have their own speed. The speed of a line is directly the result of the way in which it is drawn and is an inherent part of that line from the point at which the pencil touches the paper. It may be exaggerated by the line width or direction, but speed is generally achieved through the urgency with which the line is committed to paper. Short, fast strokes tend to create a very vital

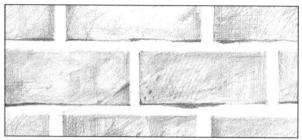

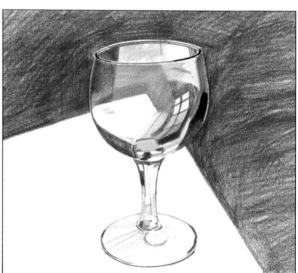

Line to create texture and form

Top, patches of strokes, some short, some long, applied with varying pressure, convey accurately the rough, broken

texture of bricks. *Above*, solid, flowing lines narrowing into shadows and thickening where there are highlights, insinuate the graceful curves of a glass.

impression, whereas long, fluid ones convey a more placid sense of movement. Lines which run in a very positive direction will likewise imply positive fast movement, and lines which meander will create a sense of varying speeds. A line which starts with a broad width and then narrows will suggest a build-up of speed in contrast with a line which starts very narrow and thickens, which will create a sense of slowing down.

It can be a useful exercise to draw a relatively simple object with line, at varying speeds - say, at one-minute intervals through to a full ten minutes. This exercise will not only help your powers of observation, in selecting what to commit to paper in a given time (which will be useful when sketching), but the results will also clearly illustrate the speeds of line. There will be a marked difference in the urgency of your linework from the first to the last drawing – a technique which will have useful and specific applications in your future work.

It is essential when using coloured pencils to remember that you are not simply creating a mark but at the same time also making a colour statement. Therefore vou must view line as a vehicle for colour and not as a structural or textural mark only.

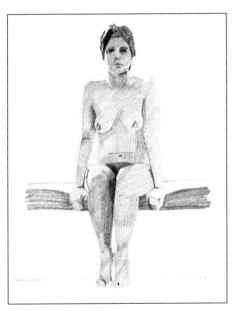

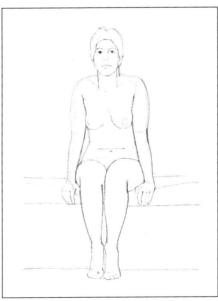

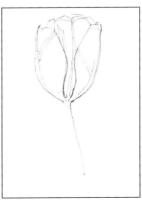

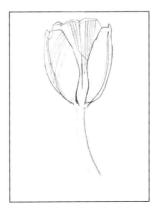

Fast sketches

Practising drawing within set times will increase your analytical powers of observation and your ability to draw the image concisely. Far left, the flower was drawn in 30 seconds, allowing only fast line to describe its shape. Centre, in two minutes the shading of the flowers was explored in short strokes. Left, within three minutes the artist produced a more representational interpretation of the tulip.

Still Life with Tulips

For this still life the artist chose just a few objects – an apple, a lemon, a wrapped bunch of tulips and irises, and a sketchbook. Each element in this small arrangement has a different texture, colour and form from the next, to add interest to the group: the apple is a smooth, deep red, streaked and flecked with light red and orange; the pitted surface of the lemon and its vivid colour provide a high contrast to the apple; the simple, heavy forms of the fruit are offset by the fussy lettering on the wrapping paper; the green letters and the striated leaves complement the apple's red just as the blue of the irises and the shadows complement the yellow lemon. The sketchbook on which the fruit is placed is used to anchor them in the image – without it they would appear to be floating in mid-air.

1 Concentrating on the colour theme of the still life the artist begins by blocking in the largest area of red, using it as a ground and as a key for working up the rest of the picture, *right*.

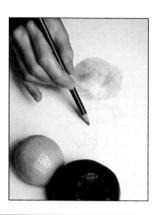

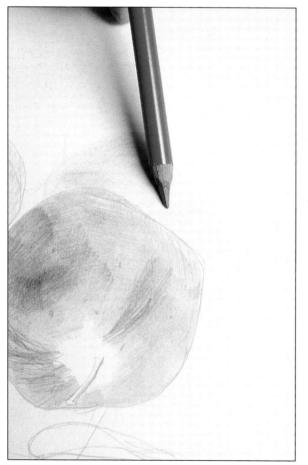

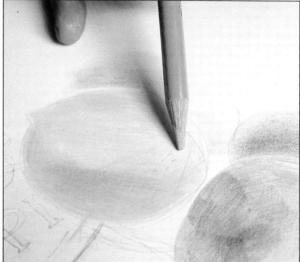

2 Working around the apple, *left*, she establishes its form in its environment by ghosting in a blue shadow behind it.

3 The yellow of the lemon is developed further, *above*, strengthening the triangle of primary colours. This group of forms and colours creates a point of reference from which later decisions about colour can be made.

6 Using bold strokes of purple and dark red applied with considerable pressure, the streaky texture of the apple skin

base colours are worked and blended into the paper's surface to create a very fine, smooth texture. This texture will later contrast with strong strokes worked over the blended colours.

4 Using a soft eraser, left, the

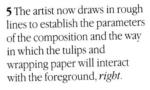

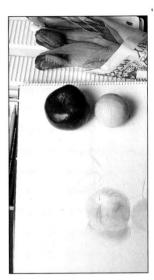

es of purple is indicated, *right*. These strokes ed with stand out particularly strongly against the smooth background.

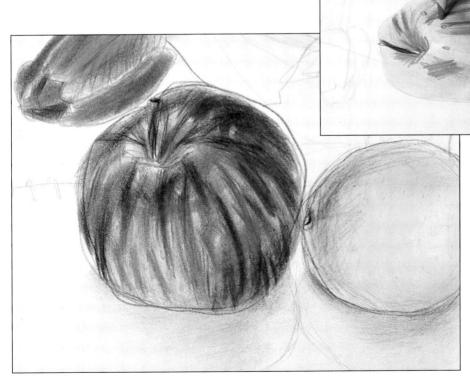

7 The different reds and the strokes used on the apple give it form. A hint of red is also applied to the lemon to indicate its slightly reflective surface, *left*. Slowly the red elements of the composition come together, linking the whole image.

9 Pale cream laid over and between darker hues conveys the glazed effect of the cellophane wrapping paper, *right*.

8 Fine blue lines are drawn over the green base colour of the leaves, the direction of the strokes creating a sense of movement in sympathy with their structure and form, *left*.

10 The soft, floating colours of this work are anchored by lines which weave in and out of them, delineating shape while suggesting movement and life, *left*. There is nothing still about this still life!

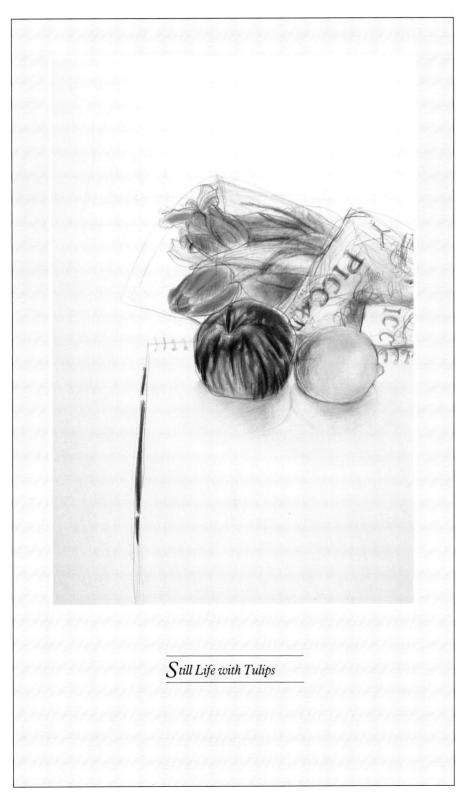

11 The solidity of the forms positioned in the centre of the final image is balanced by the thin red stroke that demarcates the edge of the notebook, and which draws the composition lower down in the pictorial space.

Still Life with Shells

The patterns on this bag decorated with shells have an abstract quality which the artist decided to explore in her drawing. Using faint pink lines she mapped out general guidelines for shape and colour. Taking two of the predominant hues in the still life she then laid the first patch of colour and built up the other colours around and in direct relationship to it systematically. Gradually the whole image area was blocked in. Using sketch-like lines and areas of tone which bleed over their boundaries, or fall short of these limits, the lighter colours were laid in such a way that they seem to be floating. Shadows have been picked out in blues, running across the darker areas, linking and blending colours. The three-dimensional aspects of this still life have been treated as lines - lines of colour, lines of texture, and lines of shape - which move and suggest potential dimension but which are themselves flat.

1 The rich shapes, textures, colours and patterns in this small embroidered purse adorned with shells inspired the artist to investigate the visual complexities of this still life, *right*.

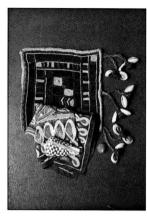

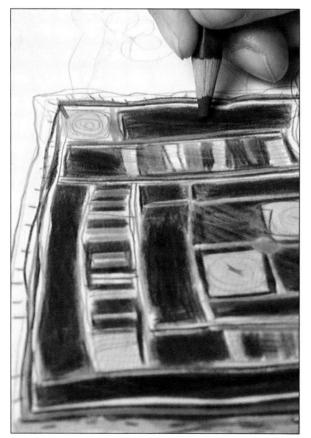

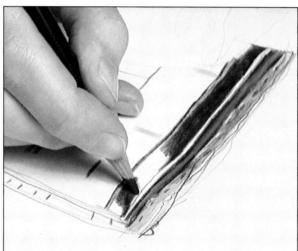

2 Using pale pink, faint guidelines were sketched in, and then the colours of each item were added. *above*.

3 Having laid the ground colour, the drawing is reworked with rich, heavy colours, deep into the paper's surface, *left*.

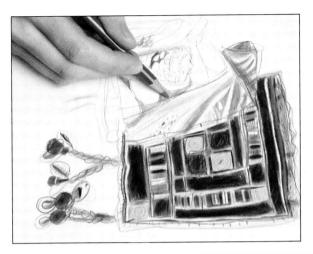

- **4** Working from the point at which the handkerchief and the purse meet an ideal key for colour reference the artist now moves farther out, slowly and gradually, *left*.
- **5** The elements of the composition, particularly the shadows, are treated as decorative devices, *right*. Here, a Prussian blue is used to suggest shadow, a colourful and exciting interpretation of reality.

6 The final work is a riot of coloured areas floating approximately within the guide of the fluid outlines. Many of the colours are laid over others; for example, in some places the artist has laid red-brown over yellow, allowing the yellow to glimmer through. Every object has a linear and tonal shape. The juxtaposition of solid areas of strokes and simple lines creates a wonderfully fresh feeling of freedom of colour.

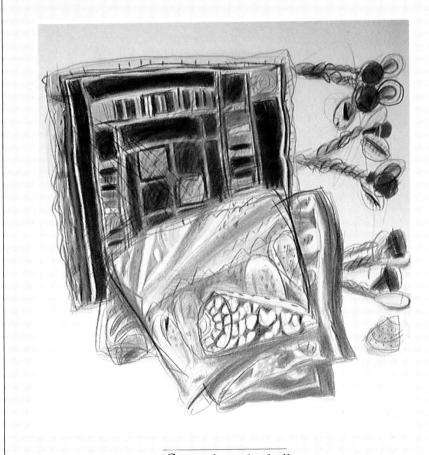

Still Life with Shells

Famie

The texture of the paper used in this work is at once the major element of its style and the determining factor in the way in which the coloured pencils have been handled. The portrait is a subtle colour composition where strokes have been used not so much for their own merits, but in order to maintain a systematic deposit of pigment on the paper surface, to produce a soft, almost misty, representation. Base colours were roughed in using pigment blocks. Overall tones were then established by carefully working over the entire drawing. As the portrait was built, so details gradually came into focus, line by line and colour by colour, pulling highlights forward and pushing shadows back to create the illusion of form without structural lines. Lines do show where they represent the texture of the hair, but otherwise they only carry colour to the surface of the paper.

1 In his sketch, right, the artist positioned the model carefully to make full use of the available natural cross-light. Together with the notes made at the bottom of the sketch he determined the colours that he felt would achieve a delicacy in the treatment of the portrait.

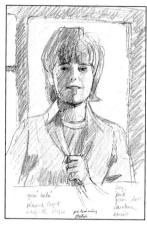

2 Some of the main colours were blocked in using pigment sticks, which are ideal for large areas of colour, right.

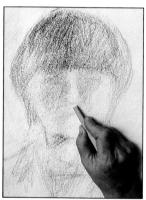

paper it is easy to remove pigment with a soft kneadable eraser, in order to accentuate highlights and blend the

3 Because of the texture of the pigments without smudging the colours, left.

4 It can be difficult to blend small areas of colour, particularly on a rough surface. Here, right, the blade of a craft knife was used to scratch and

mix the pigment in one movement, at the same time flattening the paper's surface to create a slightly smoother highlight.

5 The colour in this finished work has been applied in very even, soft layers of strokes, creating subtle mixtures by means of overlaying one colour on another. The artist has relied on the texture of the surface to create the almost stippled light effects which add to the delicacy of the interpretation. A green halo of light around the figure forms an almost linear silhouette and serves to draw the figure forward out of the intentionally hazy background. The artist used pigment sticks and crayons in grey, pink, green, dark green, cerulean, apricot, black and white.

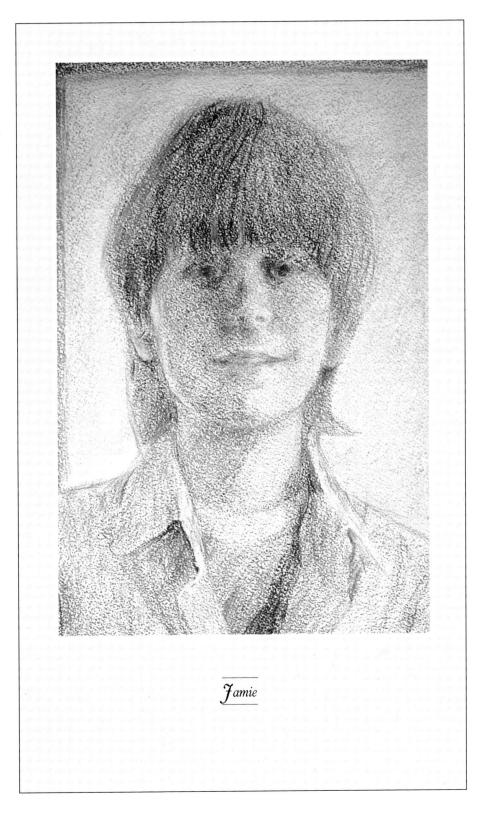

CHAPTER FIVE

HATCHING

Drawing with areas of tone is an extension of drawing with single lines and depicts a subject in areas of light and dark, colours and shadows, rather than in simple silhouette. There are two main methods of indicating tone: by imposing one colour on top of another in a continual area of flat tone, and by juxtaposing colours by means of 'parallel' lines. Hatching is the technique of drawing one group of lines in a given direction and overlaying or overlapping another group of lines in a different direction. When these two sets of lines run in almost opposite directions, in a cross-like manner, the pattern created is known as cross-hatching.

HATCHING AND TEXTURE

These techniques have been used for centuries as a drawing device and were particularly successfully used by engravers, who developed an enormous repertoire of tonal values by building up areas of hatching and cross-hatching from a simple, rather harsh, straight line. Both techniques have also been widely used to create a sense of 'colour', form and texture in a monochrome work. When using one colour, a sense of tone can be created only by increasing or decreasing the area of white within the coloured surface. This can be seen easily in the gradation of a pencil tone over a mediumgrained surface. However, by hatching or cross-hatching with colour, a more varied and complex pattern of colour density is achievable.

The lines may be thick and heavy, creating a dense texture; alternatively they may be thin and fine reflecting a highly controlled, delicate and precise rendering. Any effect which you can achieve in a single line can be heightened and duplicated by placing similar textural marks over or alongside it, offering great scope to create dimensional forms and surfaces on paper. Investigate the colour possibilities by drawing a simple hatched grey scale. Compare this to the grey scale you might create with flat tone, and the textural depth of the cross-hatched area will be self-evident. Try also applying this scale of tone to a three-dimensional object and you will see just how strong a sense of colour is possible using hatching rather than a flatter, gradated tone.

In drawing, cross-hatching has a slightly architectural quality, well suited to depicting structural forms, but it does not preclude softer, more fluid versions for depicting less hard or animate objects.

In repeating one line alongside another and in drawing one gridlike pattern over another, a vast array of 'surfaces' may be created. The specific qualities of the surface will be governed by the type of pencil used, its point, the type of paper, the degrees of pressure applied and the resultant line character. The distance apart that the lines are placed will also have distinct effects on the density and texture of the tone created. The eve will read not only the lines drawn but the gaps between them as well, thus producing an effect of negative and positive visual sensation. When the lines are close together they will be dominant, and their 'edge' will texture and colour they would

Cross-hatched pattern

When creating cross-hatched patterns it is important to determine how the lines will fit together and how they will appear in the scale of your work. Top, the lines are so widely spaced that the white gaps predominate – to provide

be more appropriate for a larger space. Centre, the grid is more balanced - it lends colour to the white spaces and its texture is more effective. Above, the lines carry more weight than the spaces do, creating more pronounced colour.

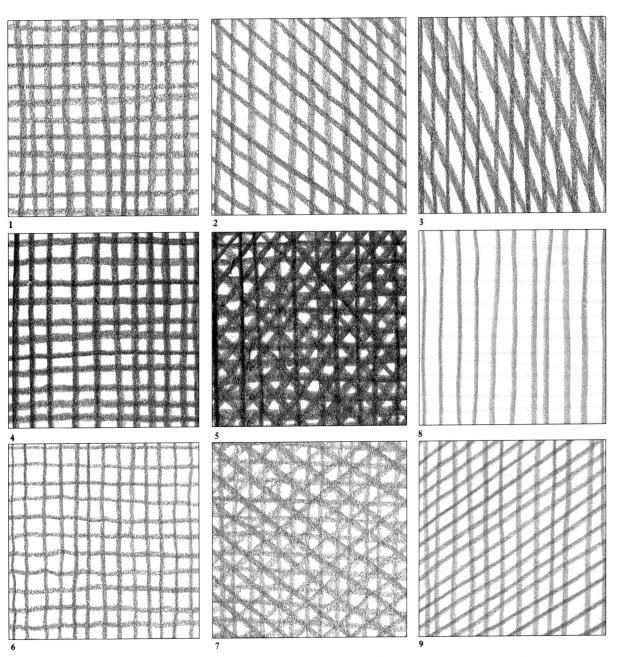

Cross-hatched effects

Lines can be cross-hatched in different directions to produce a variety of effects.

1 Cross-hatching is applied vertically over horizontal hatching. 2 Cross-hatching laid at a 45-degree angle over the hatching, as opposed to a shallow angle, as in 3.

The sequence **4**, **5**, **6**, **7**, contrasts the effects of vertical hatching and horizontal cross-hatching of different densities and then shows the effect of the addition of diagonal cross-hatching, again at different densities.

The two examples **8** and **9** demonstrate hatching and cross-hatching using the three primary colours. Apart from creating texture the overlaid colours produce new colours on the page, such as green, orange and purple.

create texture; when the lines are far apart the gaps will be dominant, the pencil line bordering the shapes.

The quality of line, as ever, is the determining element in the texture of the tone, which of course relies physically on the pencil and paper qualities used. Sharp, hard leads offer a tight intimate control ideally suited to small-scale works, whereas softer leads offer a more open technique suitable for large areas. It is important to experiment to investigate the vast number of effects possible. Creating tonal values is only one aspect of cross-hatching; there are two others - the creation of direction, and the creation of colour. By creating a stroke which starts thick and decreases in size you create a movement visually from thick to thin, from foreground to background. Within texture you can create this movement from heavy to light, taking the viewer's eve from highlight to shadow around a shape by fully developing the directional qualities of the tone. Curvature within the line will further enhance this sensation of physically seeing 'around' a subject.

By overlaying lines at a given point, or visually bending them by placing curved lines over straight lines the strength of composition of a surface can also be hinted at. Experiment by placing one group of parallel lines over another, starting with a simple grid pattern on paper. Draw a duplicate on tracing paper and place it over the original pattern. By turning the tracing gradually through 180 degrees you will see the wide range of effects achievable in simple hatching. These will range from solid strong textures formed from the overlaying of a number of grids of different dimensions at a variety of angles, in order to create a wide range of colour density and surface pattern, to a number of optical illusions which may prove useful in describing shape, when a gridlike pattern is drawn at an oblique angle over a perfectly square grid. The result of this method will be the appearance of a curve in the straight lines where none actually exists.

By varying the distance apart of the lines on one of the grids or by using a different lead and placing a tight fine grid over a thick crumbly grid, further textures will be created. Then experiment by drawing curved lines and overlay these on a straight grid pattern. The effect of a static or moving texture will develop which may be further enhanced by the colours used.

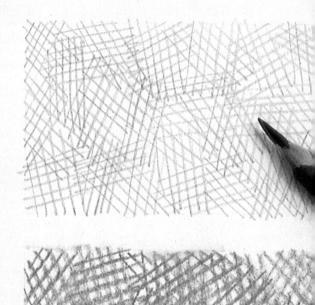

Hatching with different pencil points

The two cross-hatched areas, above, differ in their density only. The patch at the top appears considerably lighter in colour than the one below it, although equal pressure has been used on both samples. The difference lies in the way that the pencil leads were sharpened. The precise point of the pencil in the top image has produced crisp lines but in the second image the lead has been allowed to develop several facets which have created a softer, heavier line.

Cross-hatching and perspective

By reducing the density of cross-hatched lines, perspective can be created. The example, right, is a detail of the box, far right, in which a slight curve and reduced pressure produce a sense of advancing and receding form. In the example right, centre, and its detail, below right, cross-hatched patches of strokes which lighten and become thinner and smaller towards the background convey a feeling of distance.

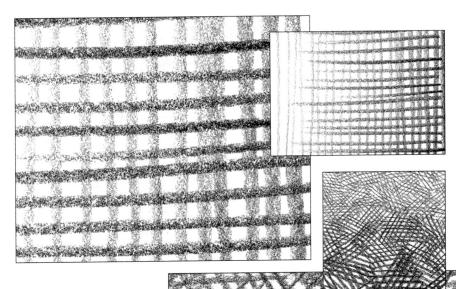

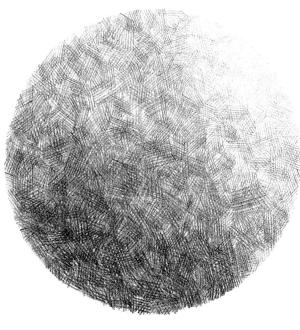

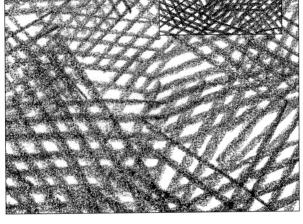

Cross-hatched form The sphere, *left*, shows how form can be created with straight cross-hatched lines, by varying the density of the line and the pressure on the pencil.

Cross-hatched grey scale *Below*, the cross-hatched grey scale indicates the vast range of 'colour' that can be achieved using pressure and line density only.

Hatched colour

The complexity of hatched colour in the illustration below is demonstrated in these four close-ups. The apparently red shadow between the two bananas, right, actually comprises hatched lines of red, orange, brown, green, grey and black. Beneath the stem of the banana, far right, the cast shadow is a subtle mixture of orange, red, yellow, green, blue, grey, black and ochre. The more reflective skins of the apple and orange carry colour even further. The cool side of the apple contains blue, but where the orange cast overlaps, red and yellow emerge, below right. Green is reflected onto the orange skin, below, far right, translated as lines of green hatched in with the strong reds and yellows.

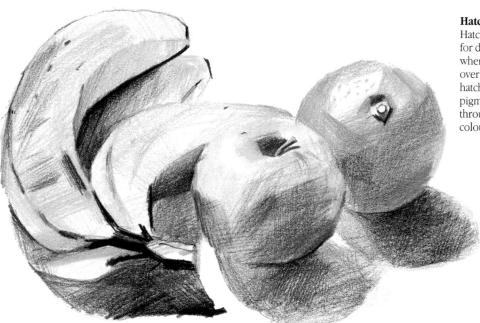

Hatched shadow

Hatching is extremely effective for depicting shadow areas where many reflected colours overlap. Using delicate grids of hatched lines, layers of pure pigment are allowed to shine through to create a complex colour interpretation, *left*.

Building up hatched colour

The colour swatches *above* show a sequence of cross-hatching in which only four colours – yellow, orange, red and blue – are used. It is usual to build up colour from the palest tone to the darkest, thereby allowing scope for adjustment before the colour becomes too dark. The dominance of colours can be seen in these samples where the

red completely overrides the grid formed in red, yellow and orange. One layer of blue lines balances the effect of the red, but two layers of blue adjust the colour balance in favour of blue. The final colour mix appears blue but in fact, of its five parts, only two are blue.

CREATING COLOUR WITH HATCHING

Because drawing with coloured pencils is essentially linework the colour of the line is important. The build-up of perceived colour can be very subtly handled through the control of different coloured lines. By overlaying one colour on another, the artist may create the effect of a new colour.

Careful experimentation will show that the order in which colours are applied also creates different effects. For example, a yellow grid placed over a black grid is obviously going to create a different impression from the one created if the sequence were reversed. It is also possible to choose a base – perhaps a dark colour – and run several near-parallel grids of different pigments over the top in alternative directions, thereby creating a dark, heavy-coloured texture. If the dark base is allowed to finish and the coloured pigments laid on top are continued, you will create a sensation of highlight and shadow, again suggesting three dimensions in the use of simple straight lines and colour.

Creating colours such as those perceived in an area of shadow, where the shadow appears to be purple-grey, becomes an exercise in the construction of colour. Layers of hatching can be built up using grids of varying scale with lines of pure pigment – reds, blues, purple, greys and black – to create a final colour of great subtlety and complexity. Gradually a tight colour mass will be created from a careful combination of open and close-worked hatching.

THREE-DIMENSIONAL HATCHING

It is possible to create a sense of dimension with cross-hatching in one simple colour by developing thick and thin strokes, wide open and tight grids, but when this facility is coupled with the addition of many colours, the opportunites for creating complicated tone and colour are endless. The direction of a piece of hatching may give the illusion of three dimensions, particularly if the strokes are thicker in the foreground and tail off into thinner lines as the background recedes. When this is subjected to the dimensional properties of colour, the form created will develop even greater shape. By using the bright highlight colours up front and combining grids of darker hues as the shadow area forms, the subject depicted will convey considerable depth.

Sunset

The sun setting over the sea often produces such a blaze of colour that it is irresistible to paint. It provided an ideal challenge to the artist to draw it using the three primary colours only, but by overlapping and juxtaposing them with sweeping hatched and cross-hatched lines, he produced a range of new colours. He recreated the movement of light that occurs as the rays bounce off the sea, mirroring the sinking orb in the pattern produced on the water.

- 1 Using broad sweeping strokes with pigment sticks, the artist creates the framework for the illustration in blue and yellow, leaving plenty of white space for further colour, *below left*.
- **2** Roughly following the lines of blue and yellow, broad strokes of red are drawn in, mixing the background colour in the eye of the viewer, *below*.

3 Having established the bold colour treatment of the sky area in hatching, the same colours are now applied to the sea, but with cross-hatching, right. Lines are drawn using the three colours in strict sequence vellow and blue, then red. Despite an ad hoc appearance, on the whole they follow a movement from top left to bottom right. The foreground colours appear to be denser than those in the background because the lines are closer together.

4 The whole composition has been sketched in place, far left, and the artist now concentrates on building up the colour.

5 Blue and yellow are worked up to add density to the foreground, whereas red is used to strengthen the crosshatching of the sun and its rays,

6 The finished sunset has a beautifully free feeling created by the loosely worked linear grid patterns. This is an excellent example of how coloured lines, hatched and

cross-hatched, mix in the eye to create colours that are actually not applied - purple and green, for example. There is an urgency in the composition which suggests a fleeting

moment caught on paper simplicity is its success. The artist used pigment sticks only because they allow thick broad strokes to be created, and cover large areas quickly.

Irises

An almost monochromatic scene has been injected with life by a shaft of light piercing through the window. The vivid purple and yellow of the iris flowers positively glow in this cool room where time seems to stand still. Beyond is the hint of a warmer world – inside, large cold spaces which take their life from the texture of the hatching only stand poised, like the black table wedge which is cantilevered across the middle foreground, anchored by the edge of the page. The whole composition has a strong linear quality, which embodies a tension that is released only in the flowers.

1 In this photograph, *right*, a shaft of light through a window illuminates a cool shadowy interior, always an exciting temptation to the artist. Such natural spotlights create beautiful extremes in lights and darks.

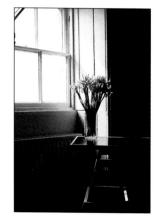

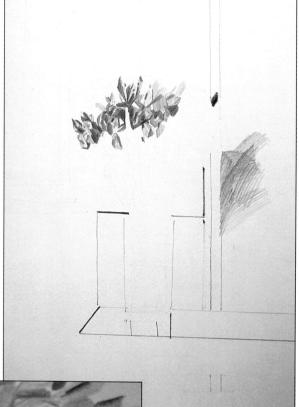

2 Having sketched in the basic framework of the picture in deep grey, *above*, the artist then concentrated on the focal point – the flowerheads – working up the intricate colour planes en masse. He used ultramarine, dark violet, light violet, and Prussian blue.

3 Colour was applied to the flowers using broad, strong strokes, starting with the palest colour and working through to the darker hues. Spaces were left for the finishing highlights of Naples yellow, *left*.

4 The shadowy monochromatic background is too plain to be treated as a totally flat expanse of one colour, so a complex stroke pattern of hatching and cross-hatching is applied to create texture within the colour, quite independently of the paper's surface, *right*.

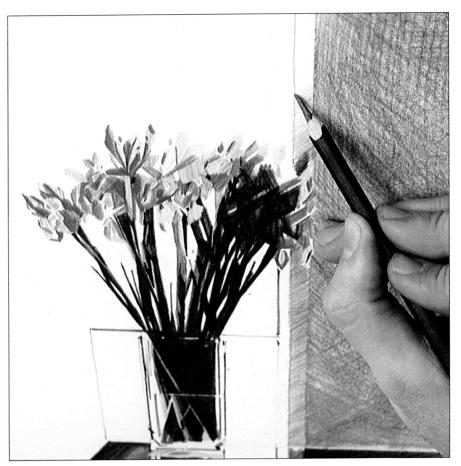

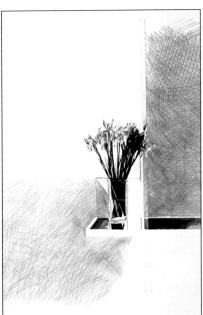

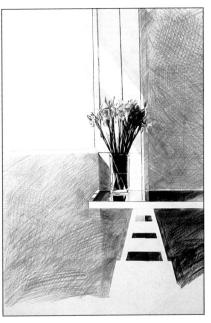

5 The large areas of hatched background above and to the left of the vase of flowers are treated as balancing areas of tone within the composition, pivoting on the diagonal, *far left*.

6 The visual balance is substantiated by balancing the vase of flowers on the 'fulcrum' on the table. Beneath the table surface a dark area of crosshatched black is added as a balance to the dark hues in the greenery of the flowers, *left*. The hard edge of the table was created by hatching against a ruler.

- 7 The intricate geometric patterns created by the stems of the flowers and their reflections in the glass vase are treated as a collection of coloured shapes, above left. Unlike the background, which is handled very gently, heavy pressure is used here to give force to the main elements of the composition and make them stand out from the background.
- 8 Silver grey, blue grey, raw sienna and raw umber are hatched over the glass areas of the window, *above*, the strokes made in one direction and applied very evenly, with consistent, though light, pressure.
- 9 The areas of glass are worked over with a putty rubber using long strokes to remove some pigment and smooth out what remains. This leaves slanted areas of white paper showing through the colour, which indicate the reflective nature of the glass surface, *left*.

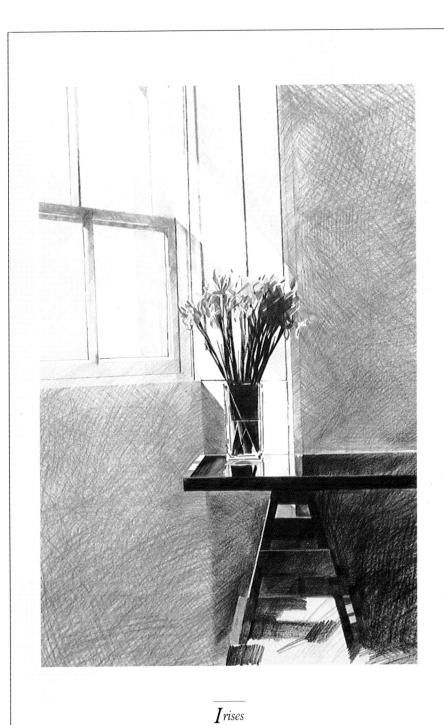

10 The finished drawing shows how the hatched background is cleverly given its own texture and interest and contains much more dimension than it would as a flat colour. At the same time it offers a superb foil to the heavier, tightly worked elements of the composition.

Plantation

Using a system of carefully placed areas of cross-hatching the artist has created a very positive colour statement, integral with a structural style. Colour grids have been applied one over another to create areas of texture and tone. Overlapping hues have produced very complex colour mixtures which stand out against the white background like shadows on a wall – blue behind yellow, red behind green. The directional nature of the lines creates both static forms in the trees which rise in serried rows from the plain, and moving texture in the sky where wispy clouds float over the distant peaks.

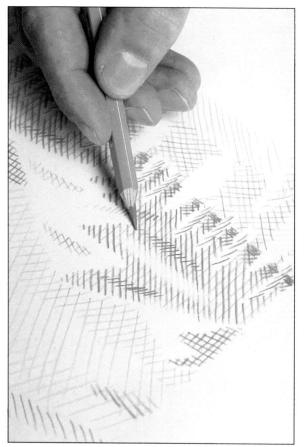

3 Yellow lines were laid across the foreground and in the white areas to convey the warmth of the evening light, *right*. Long, straight yellow lines drawn

across the sky lend a still quality to the sky, at the same time highlighting its expanse.

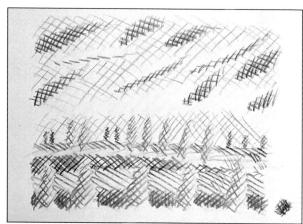

1 In this preliminary sketch of a cypress plantation, *above*, the artist quickly established the colours he will use for the final drawing, and the way he has laid down the colour suggests the

style and treatment he should use in it. From this point it becomes almost a mechanical exercise to produce the finished image.

2 Left, the first stage is hatched in on the paper in blue, leaving areas white where the colours are not intended to mix with the blue. The blue pencil has been used with varying pressure to

create light and dense lines. The way it has been sharpened has allowed thick and finely hatched grids to develop, which gives the image depth.

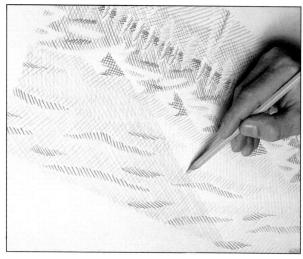

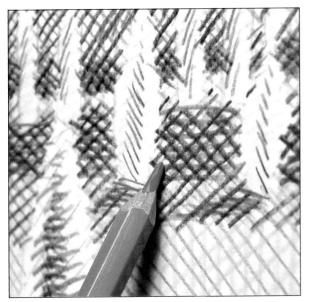

4 This close-up, left, shows how cross-hatching with different colours creates an optical mixing of colour. Red applied over blue creates a purple, red hatched across yellow produces an orange, and blue over yellow creates green. By overlapping grids at different angles great depth of colour is achieved. Straight lines have been used for the background to contrast with the slightly curved strokes on the cypresses which exaggerate the rounded form of these trees.

5 In the completed drawing, *below*, the many lines and few applied colours combine to form a cohesive whole. The dense build-up of lines in the middle distance forms a solid base against which snowy white peaks of the horizon and the white edges of the cypress trees are highlighted. It also provides a visual mid-point in the composition.

The Dancer

Starting with a photograph of a seated dancer the artist drew a couple of sketches in order to plan and reorganize the structural and colour elements of the picture into a more desirable form. Having drawn in the areas of the composition as a pale linear structure by retracing the sketch on a lightbox, he then proceeded to block in the major areas of tone. He started with the background as a basis from which to 'fill in' and to which he could relate the colours of the figure. Hatched grids of pink and yellow overlap to create an open, stage-lit background in direct contrast to the heavy purples and black of the dancer's dress. The same colour texture is again picked up in the flesh tones, creating not only a sense of unity in colour and style but offering at the same time a foil to the textured treatment of the hair and dress, and the looser, curved hatching used to depict the feather fan.

1 Using a photograph of the dancer, the artist worked out a rough colour sketch, experimenting with the composition and colour on the drawing, *right*.

2 The drawing was enlarged and traced down, using a lightbox. The background is now worked up with curved strokes of cross-hatching, in pink madder and light yellow, below. The overall impression that results is a beautiful warm, apricot glow, below right.

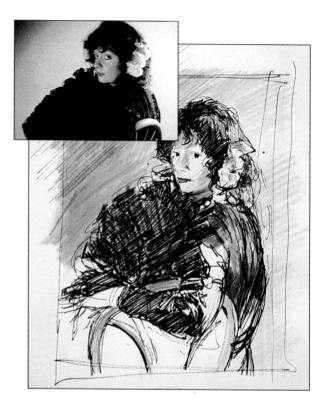

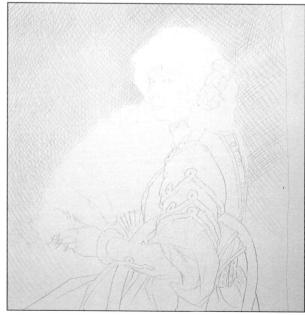

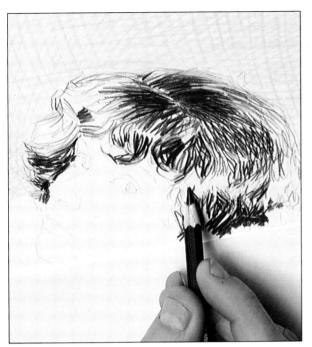

4 Using very distinct areas of cross-hatching the artist lays colour into the structure of the face. Pale browns form the basis of the grid system, becoming

tighter in areas of shadow where blue-violet has also been used to suggest a deeper colour *right*.

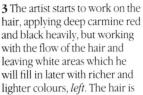

one of the richest colour areas in the composition, so it serves as a good guide to future colour decisions. The artist has covered the image with paper so that his hand doesn't dampen the paper or smudge the pigment.

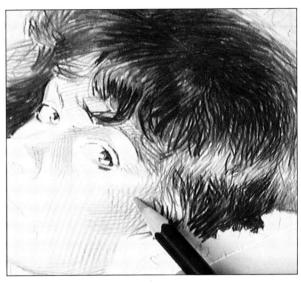

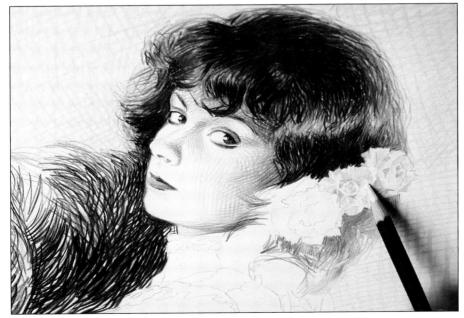

5 Each element of the composition is worked up separately. Here, *left*, the flowers in the dancer's hair are left very pale, with touches of grey-green and blue-grey being used to suggest shadows between the petals. Soft yellow tinges the flowers with a warm highlight and echoes the yellow highlight on the hair.

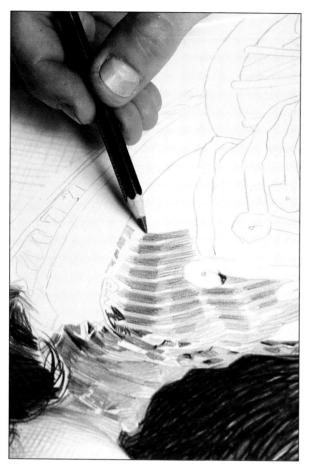

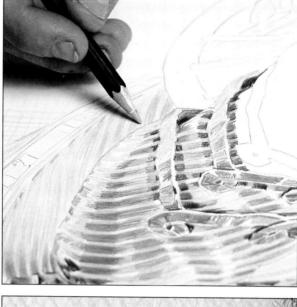

Above, the striped satin of the dancer's dress is represented as a series of closely worked lines of tone. Shadows were created by producing a dense area of pigment, using more than one layer of colour rather than by applying greater pressure on the pencil. The colours were laid in strict sequence, working from the top of the portrait downwards to prevent smudging.

7 Above right, reflected colour from the background is picked up in the back of the dress with delicate strokes on lilac. The colour cast is drawn into the stripes, gradually replacing the black and purple.

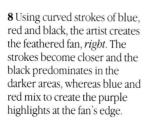

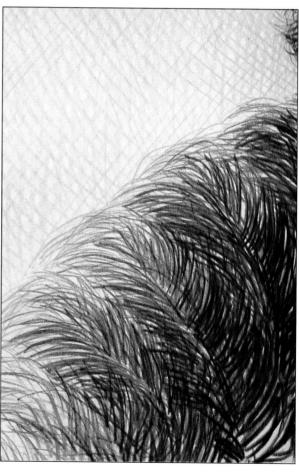

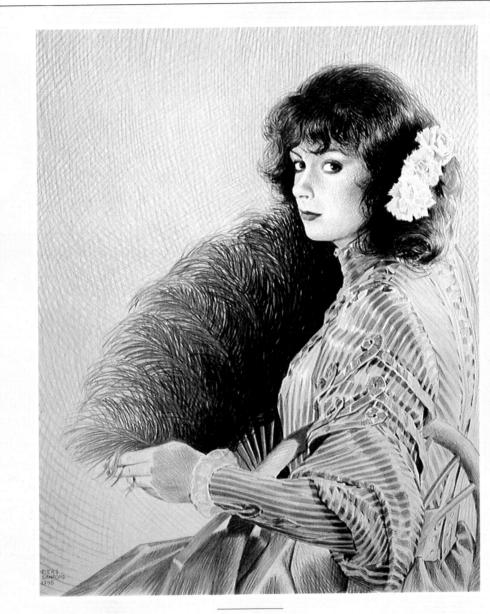

The Dancer

9 The finished drawing is a good example of the complexity of colour and the directional qualities of line that may be

achieved with hatching and cross-hatching. With very fine linework, the hatching is barely discernible in areas.

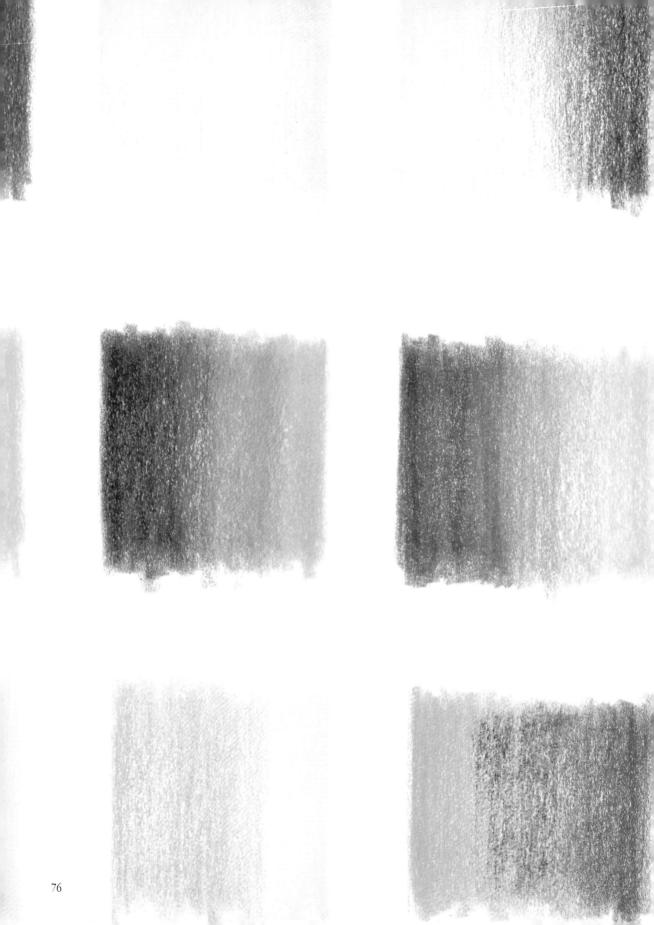

CHAPTER SIX

CREATING COLOUR

In most painting media, the colours are pre-mixed and then applied to the working surface, but in the case of coloured pencils the colours must be created on the surface itself. The medium thus necessitates careful analysis of the way the colour is made up in any subject, since by applying several pure pigments to a surface in order to build up a secondary colour, you are in effect reconstructing the component elements of the colour perceived.

Pencil pigment is semi-opaque, which means that a multitude of colours can be created by layering them in varying amounts and with varying pressures. When developing these colours it is important to remember that you are drawing shape, mood, life and scale with each colour depicted. Do not fall into the trap of seeing your subject as either a monotone composition to which you have to add colour, or a group of shades or outlines which have to be filled in with colour. Colour is the essence of your work – it is neither superficial nor an afterthought!

Think of a shimmering fish or the plumage of a bird, both of which pulsate with the most fantastic colour – colour of such vibrance as cannot often be found in other living forms. Yet when we see the same creature dead its colouring becomes flat, dull and lifeless, with the colour to all intents and purposes drained out of the creature. In fact it has been, because colour is alive – an integral part of being. Just as we cannot regard the dead bird or fish as the same creature as it was when alive, likewise we cannot view life detached from colour.

In creating colours with pencils you are actively mixing pigment and developing blends of hue, intensity, lightness and darkness. There is a basic palette of colours which is necessary to recreate the colours that we see. These are the additive and subtractive colours of light. But because light and pigment do not fully correlate in their colour-mixing properties it is necessary to develop a palette of coloured pigments which will visually achieve the same effects as those of light.

It is a good idea at first to buy a small box of coloured pencils. The colours in such a set are selected to offer a wide range of possibilities and you will find that they provide a manageable palette. They will also encourage you to discover the vast spectrum of created colour that is achievable from a restricted starting point. With large boxes of coloured pencils it is all too easy, when beginning, to reach for the nearest approximate hue without developing the colours' mixing potentials. The strength of the medium lies in the range and purity of the colours that you can achieve through layering, mixing and blending.

Colour and paper texture Cross-hatching over different surfaces often produces a change in emphasis of colour as demonstrated in the

change in emphasis of colour, as demonstrated in the examples, *right*, in which the same colours were used, applied in the same direction, but on different papers.

The same pencils were used to create the examples, *right*, but the different papers used affected the colour of the cross-hatching produced.

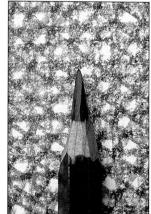

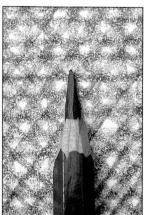

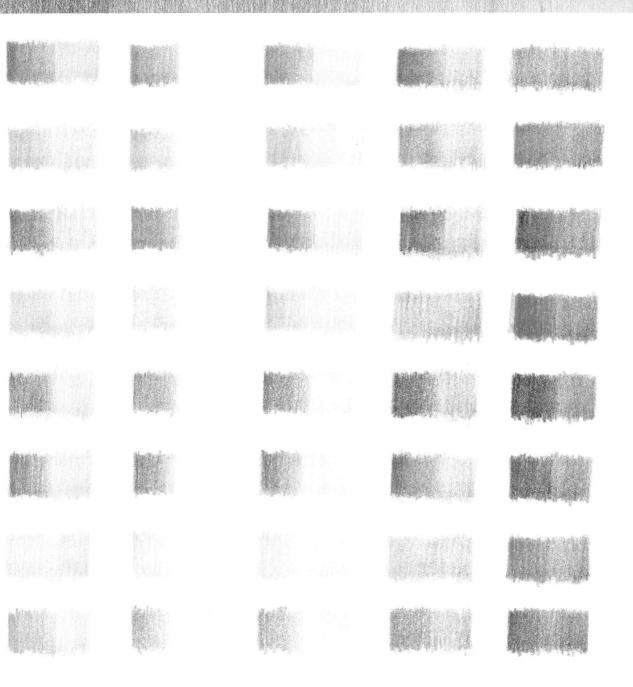

Blending colour

The swatches of colour, *above*, illustrate the huge range of blended colours that can be created on the paper, and how colours change when laid over others. From left to right, green, yellow, orange, blue and red

were laid. Coloured over them, from top to bottom, were red, orange, magenta, light blue, dark blue, brown, light green and dark green.

Creating Colour

Colour gradations

Two sets of colour gradations – warm yellow to red and warm yellow to cool blue – are illustrated *right*. The left-hand column in each set was achieved using considerable pressure on the pencil, and the right-hand column was created using very little pressure.

Below, using heavy and light pressure with one pigment – black – it is possible to produce a range of tones from black to pale grey.

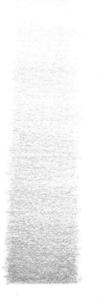

Tonal range with three pigments

The mixed colours *right*, show how a dramatic range of colour can be created using only three basic pigments. Despite the translucent nature of coloured pencil pigment, some colours will dominate others according to their natural intensity – for example, red dominates yellow, and black dominates most colours.

Tonal range with saturation

When two colours, graded totally, are applied side by side, we can compare their relative tonal densities and their potential to blend and create new colours, *centre right*. The range of colour achievable from one base pigment depends on the saturation of the pigment on the paper surface and the density of pigment in the pencil lead, *far right*.

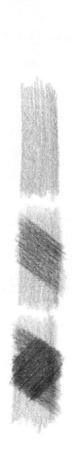

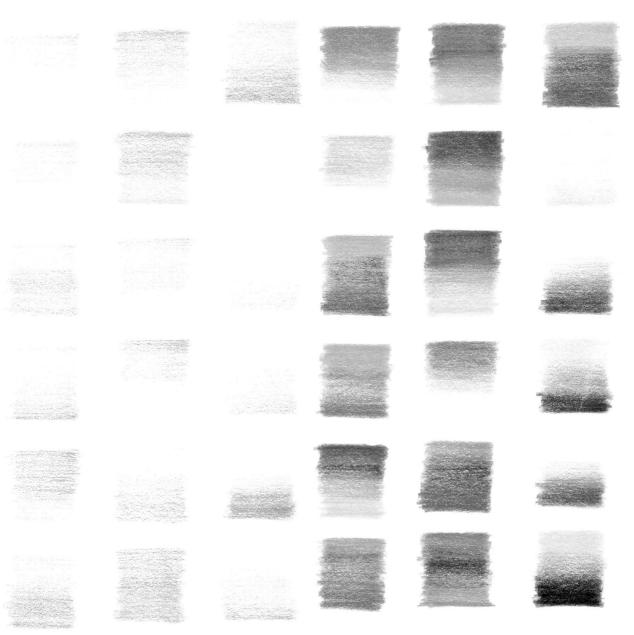

Low and high saturation

Above, two blocks of colour mixes each are shown. The left-hand panel demonstrates colours with low saturation and the right-hand panel colours with high saturation. These blocks were produced with the same type of coloured pencil but with different pressures. In each swatch two colours have been applied so that they meet

in the middle and blend. In effect, the panel depicts over 100 colours, achieved using only 36 base pigments. It is essential to take a set of coloured pencils and put them through their paces in an exercise such as this, in order to assess the mixing potential of each colour. The task will highlight some interesting possibilities which, with

practice, will become an automatic choice when you are working on a drawing.

ASSESSING YOUR SUBJECT

your subject. View your subject as a whole and see how reason we see it in the terms in which we see it. From each colour relates to the whole. Then select various this type of observation you will be able to experiment points of the subject and think of the colour seen in and with your coloured pencil pigments to build up the raw out of context. This will help you to determine the material, the subtle reality of the colours you see, from order of colours within your subject and to decide how you are going to treat them.

Think also of the dimensions of your colour. An orange sitting in a bowl of fruit, for example, will not appear as bright as if it were sitting on a black sheet of paper. It will not have the same lights cast on it and will not cast the same shadow. Shadows tend to dissolve into the background on black whereas in the bowl of fruit they are immediately apparent. An orange also has a reflective surface, so it will pick up and reflect colour in its immediate vicinity. Different colours will be cast from the fruits in the bowl, whereas from the black paper a greyness will be picked up. All these colours combine to make a colour we associate with orange.

By viewing objects analytically in this way you will When you start to draw, analyze the colour content of develop a keen sense of the reason for colour and the pure pigment.

THE INTENSITY SCALE

Arrange your basic pigment range in a line and make a strip of colour with each pencil, leaving gaps between each colour. Use medium pressure to create the first strip, then go over the central areas of each strip with the same pencil, using greater force. This pressure will deposit more pigment on the paper surface than in the lighter areas, and with maximum pressure you will achieve an area of heavily saturated pigment. This will be as near as you can get to the same hue as the pencil lead itself and will be the most saturated form of that colour you can obtain with the pencil.

Blending techniques

The colour swatches, right, demonstrate how various colours result when a limited number of pigments, applied in different ways, are combined. The top row shows colours mixed by cross-hatching. Beneath them is a row of flat tones created by overlaying the same colours. The swatches in the bottom row were produced using the same colours but applied with short strokes.

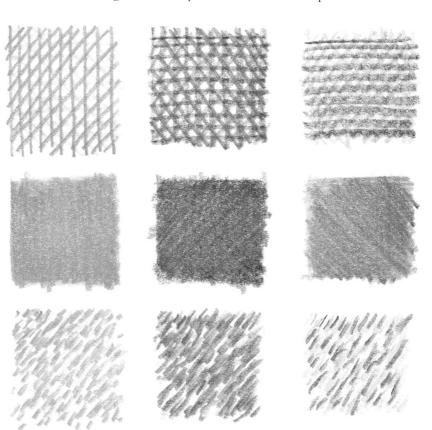

If you then fill in the gaps between each colour with graded pencil pressure, becoming lightest where the two colours join, the strip of colours you have drawn will demonstrate the scale of intensity that is achievable with your pure pencil pigments. From the lightest point you will create the effect of 'lightness' by allowing the underlying white of the paper to act as a complementary part of your colour. The less discernible the area of white the darker the saturation of the pigment will appear. This scale parallels the grey scale – the breakdown of tones from solid black to white.

The effects you achieve this way apply in principle to all colour creation because they show the extent of each colour and are restricted only by the qualities of the lead used and the nature of your paper surface. If you draw on a relatively rough texture, for example, the pigment will be taken up by the paper's grain, collecting on the high areas and leaving the low areas white; the most even uptake of pigment will occur when it is applied with medium pressure on a smooth-grained surface.

LAYERED COLOUR

Develop the intensity scale experiment further, allowing the adjacent colours in your strips to blend over each other. Combining colour in this way you will see that you can create a range of very different hues. If you try mixing colours from your box with varying pressures, you will find that the range of potential colour is increased. You will also discover that not only pressure but also the sequence of applied colours is directly linked to the creation of quite different hues. For example, if you take a number of pairs of colours, lay one over the other and then reverse the sequence, very distinct hues will result which, when combined with varying pressures, will expand the range even further.

Try laying smooth areas of red over yellow and yellow over red under varying pressures to test which pigment has a colour dominance in given circumstances. Then try laying one colour over another in a grid, starting with a loose grid and ending by creating a tight-knit grid.

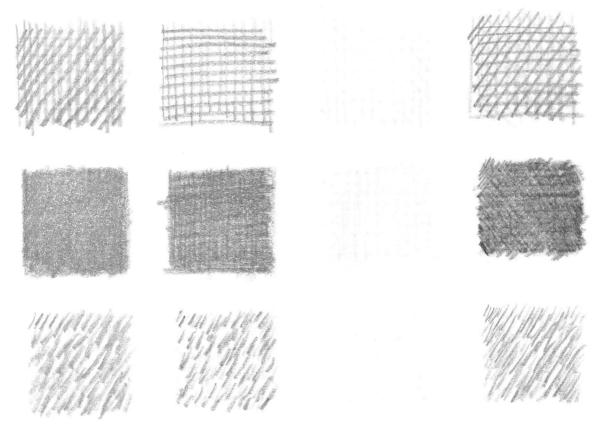

Again, one colour will prove to be dominant, but by overlaying in this way you will create complex colours which will have dimensions that flat, pure pigment lacks. Pure pigment will look as if it is just sitting on the surface of paper, whereas adding a lighter or darker hue will give a depth of colour, and heighten or reduce its intensity. Other colours overlaid to darken or lighten a colour will increase both the pigmentation and texture of the colour, turning a flat surface into something alive.

Colour mixing with fairly light tones is easy, but when pressure is applied it becomes increasingly difficult to alter the hues of darker colours by overlaying a lighter colour. Pale yellow, for instance, may be considerably altered with dark blue, but dark blue laid over with pale yellow will show little difference. Only boundless patience and experience will tell you which sequence to select to achieve your desired colours.

BLACK AND WHITE

Minor colour effects and changes may be obtained with the careful use of black and white. When seen as a shadow, black is not pure black but a mixture of hues. Shadow, after all, is only an area which is not illuminated. We may not see colour in it, but it doesn't follow that colour is not there — it is just not immediately visible and, in fact, all the colours present in a lit area are present in some form in the shadow.

The Post-Impressionist painter Georges Seurat (1859-91), inventor of the technique called pointillism, showed how a seemingly grey area is in fact a mixture of a great many pure colours. He also demonstrated that using a fine combination of lines, hatching or dots, you can build up colours from complex patterns of pure pigment. When viewed from a distance they will be seen as simple colours. We can lighten or darken any colour this way without introducing either black or white pigments, creating a richness which pure pencil pigment will not achieve.

If you apply a selection of colours with various pressures and overlay black and white, also with graded pressures, you will find that white overlaid on a range of colours will give a chalky appearance to all the colours, whereas black will darken and, to some degree, deaden their intensity and hue. Both white and black have the effect of coating the drawing surface if used throughout,

acting as a colour moderator. Colours under white become adjuncts to white, and colours under black become shades of black which, if laid too heavily, will kill the colour and make it flat.

COLOUR TEXTURE

When you are creating colour by imposing one on top of another, or by running one alongside another, or as a pattern of random dots, consider also the colour texture you want to create. Flat tonal areas tend to project a smooth surface appearance which at the same time has static texture. But by using line as a vehicle for your colours you will achieve a duality in that your line will convey movement as well as colour.

Colour built up from lines either over or alongside one another will add shape, direction and texture to the form. Using compilations of dots achieves probably the greatest complexity and texture possible, but it is also one of the most laborious methods of laying colour. Even when you move the pencil rapidly to create areas of dots in a random fashion it will take a considerable time to cover even small areas. It is a tight and highly controllable technique, ideally suited to small works, but if the work is too great in extent the technique will not achieve its aim, because the colour and texture will be lost rather than heightened.

BLENDING

Creating colour using solvents, water or blenders manufactured for the purpose will also further extend the range of possibilities. All solvents break down the pigment bonding agent and float minute particles of colour across the paper surface, allowing very subtle mixtures to be achieved.

When you have tested all the possibilities within a small range of coloured pencils, then it is time to try to apply the techniques learned to a greater range of pigments. Do remember, though, that the colours you create yourself are going to be of greater appeal and interest than bought colours. Seurat created paintings of enormous colour range using a palette of only eleven pigments — manufacturers have today put at your disposal pencil ranges of more than seventy colours, so the potential available is absolutely huge.

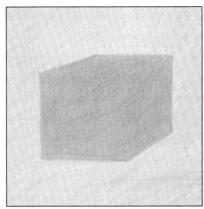

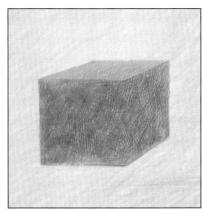

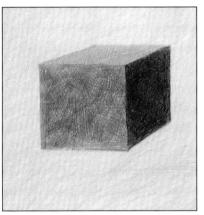

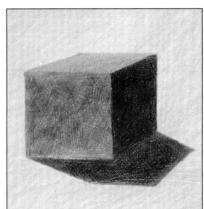

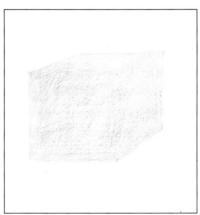

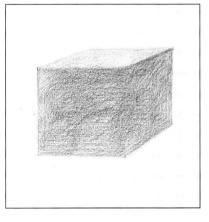

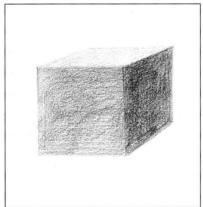

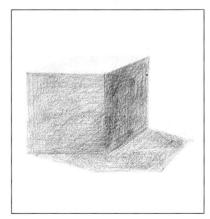

Colour and illumination

The sequence *above* reads from left to right, top to bottom. A flat coloured shape is drawn on a white background. It has form only through our association of the shape with a familiar object. The same shape is then put on a coloured background. Part of it is then coloured a darker red – it now has two areas of colour but still lacks form. A

third colour is added which suggests that the form has three sides. By adding a shadow to the form the idea of a threedimensional object is substantiated. The creation of form in this way works in monochrome as well.

Bathers

This composition captures a passing glimpse – a static moment in time, where bathers stand motionless, watching the midday sun sparkle in the gentle ripples of the shore. The image is cool in its handling and in its colour but the suggestion is of heat, created by the contrast beween the white lights of the water and the deep cool shadows of the bodies.

The artist has composed the colour very gradually, first blocking the figures, then building up zones of background around each figure until the background merges to form a continual blue-green sea. Having laid the foundations he has reworked the colours, adding depth and creating highlights while balancing the hues to give an overall harmony.

1 Preliminary sketches were made from this image, to experiment with colour mixing, particularly in the sun-tanned flesh tones where deep rich colours were desired, *above*.

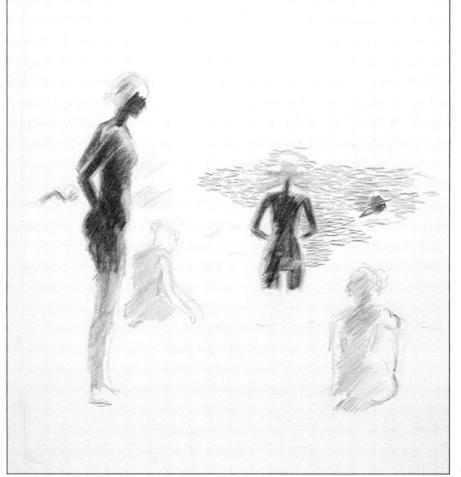

2 Once the central figure was blocked in, the other bathers were added one by one to establish their interaction and the resulting shape of the composition before the background was started, left. Colour was built up layer by layer, returning to the first figure as a constant source of reference. The sea was worked up gradually in patches of short strokes, linking the individual elements. The contrast between the kingfisher green and ultramarine of the sea and the complementary red of the figures heightens the impression of intense sunlight.

Left, leaving halos of white highlight around the figures the artist gradually builds up the red, brown and yellow colours in the tanned bodies to throw them into deep shadow. May green and yellow are used to define the girl's chest and the right shoulder of the figure in the sea. These hot, bright colours offset the cool blue of the sea.

4 Dark tones of burnt carmine and madder carmine are applied to the figures to contrast with the vivid, bright sea *below*. These dark colours also bring the figures forward from the background.

Burnt carmine is also added to the figures in the foreground. Here, *left*, its juxtaposition with the bright May green on the girl's hair accentuates the heat of the colour.

Creating Colour

6 The artist then colours up the sandy hummock in the foreground. Having laid a loose foundation of ultramarine for the shadow, and pale green and brown ochre for the raised illuminated part of the mound, he develops the colour further with violet and viridian, right.

7 The zigzag patches of the sea, left white to depict the reflection of light from the rippling water, are worked over lightly with lemon yellow to intensify the greenness of the sea (yellow over blue creating green) left.

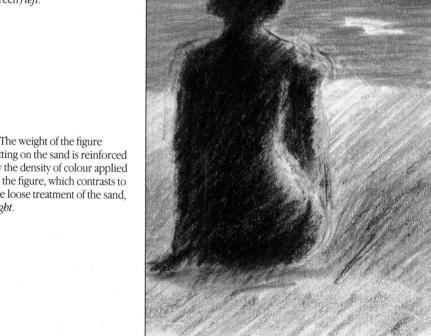

8 The weight of the figure sitting on the sand is reinforced by the density of colour applied to the figure, which contrasts to the loose treatment of the sand, right.

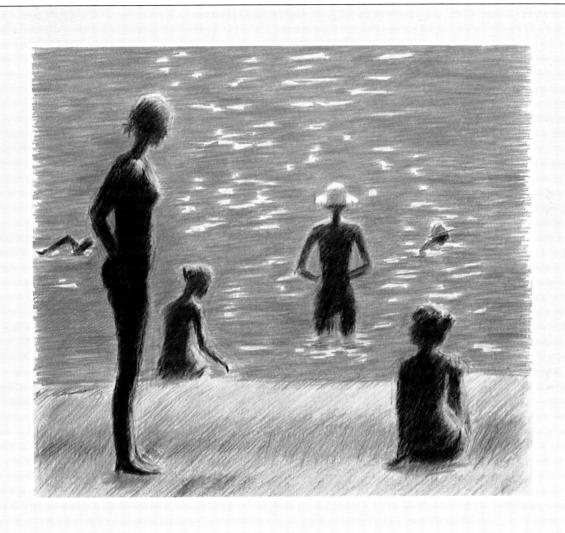

Bathers

9 The very contrasted treatment of colour in this work serves to illustrate how much may be said with colour without, at the first glance, using many different pigments. The tight way in which colour has been controlled here adds to the

sense of still calm water even where the swimmer seems to crawl along silently as if caught in a pose. The heat and coolness, brightness and shadow of the colours convey sensation and lend this image three-dimensionality.

Espadrilles

The shapes formed by intense lighting on the espadrilles are seen by the artist as negative and positive areas of colour – shapes as opposed to three-dimensional objects. Using the shadows as a starting point the artist gradually worked over the still life drawing putting in the negative dark areas in line and solid colour, leaving a silhouette of the shoes to be filled in later with brilliant colour. The almost chiselled quality of the folded canvas creates striking contrasts. Highly lit planes and deep cool shadows are exaggerated where the stripes of the red shoes weave in and out of the sunlight. Working heavily over the colours the artist draws the shadows into blackness and extends them to form a shadow cast by a window frame. Having laid the light grey tracery, the pigment was consistently worked over with an eraser, and burnished firmly into the surface of the paper with directional strokes.

1 A row of espadrilles along a wall became an interesting composition when lit unexpectedly by strong light from an opposite window, casting delicate shadows, *left*.

2 Having very faintly indicated the areas of the composition with graphite pencil lines, the artist proceeded to block in the areas of shadow in a very positive way, with strong black shapes. Against the black shapes the striped espadrilles were drawn with heavily saturated colour, using different tones of red for the light and dark areas, right.

3 The rope soles are created using two shades of ochre with little dots of red where the canvas shows through the embroidered toe, *below left*. The stripes on the red shoes are laid in a light shade of red rather than white.

4 The flatness of the foreground is captured using only one midgrey. By creating a texture with hatched strokes the artist has given some lift to what might have been a monotonous area, below.

The cast shadow of the window frame was drawn in with bronze, Prussian blue and ivory black. The artist now works over this gently with an eraser to smudge the colour into the paper and spread it along the lines of the strokes to create the streaked effect of sun through glass, *above*.

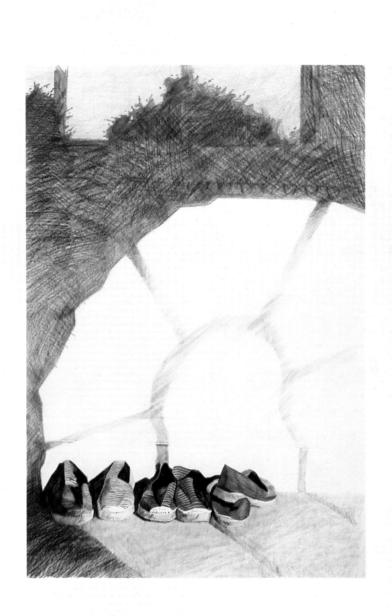

Espadrilles

Tricia

The artist chose to portray a close friend of his, because she would be more relaxed while he painted her portrait than a stranger would be. Having traced a very accurate network of guidelines using a lightbox he proceeded to draw in the background with increasingly strong strokes, resulting in a very controlled build-up of pigment. The bottle green colour forms a backdrop and acts as a key against which the darkest areas of tone are then drawn. A portion of the model's sweater is coloured up to offer a balance for the flesh tones which are then applied in very delicate layers under a magnifying glass. The artist often uses a magnifier so that he can exercise a precise control over his colour mixing. Using extremely delicate soft strokes the skin colour is built up over a flat pigmented base – almost a parallel to the way in which the model might apply make-up, working from the lightest tones to the darkest, from the palest to the brightest.

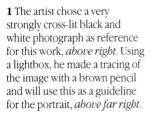

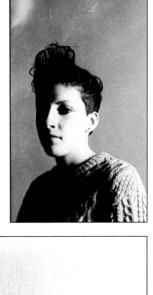

2 With delicate regular upward strokes of olive green he blocks in the background, left, taking care at all times to maintain an evenly sharp pencil point. For this an electric pencil sharpener was used.

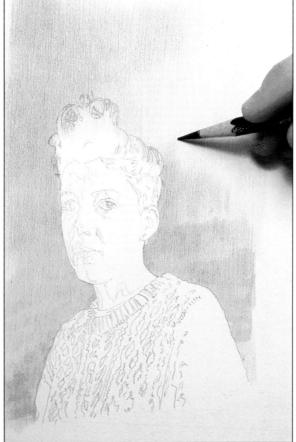

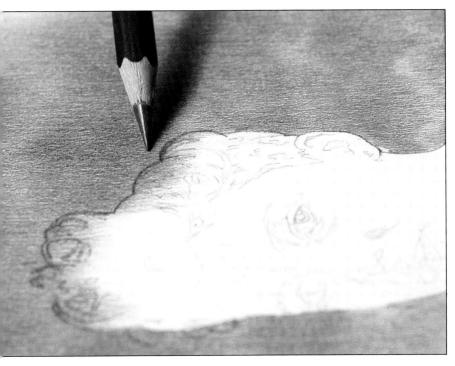

3 Over the olive green the artist places careful layers of bottle green and then dark turquoise, Prussian blue and Delft blue, *left.* Ridges of olive green are left so that the result is a complex deep colour with inherent texture.

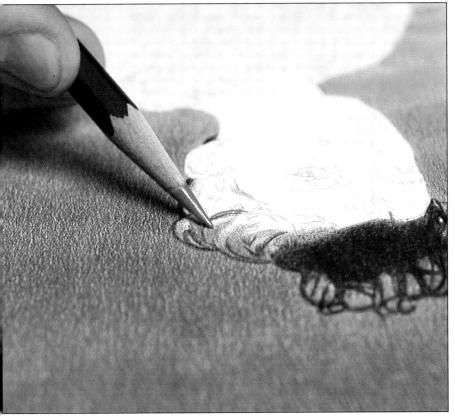

4 Having firmly established the colour of the background, the artist now starts on the head, working almost systematically from top to bottom. Using ultramarine and indigo as an underlayer he colours up the hair, *left*. These blues give the later black layers a glow and depth which they would not otherwise have had.

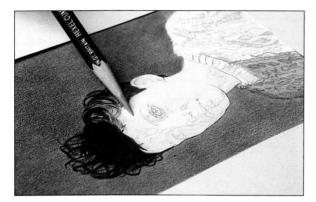

5 A pale raw sienna flesh tone is laid as a foundation to the skin areas, leaving highlight areas pale and increasing pressure over the shadowed zones, above.

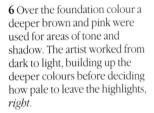

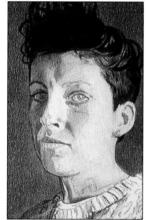

7 Carefully masking off areas to enable him to see the tones working together, the artist used a magnifying glass to allow him greater accuracy and for drawing in fine details such as

the eyelashes, eyes and edges of the ears, *above*. The colours are built up very slowly to create a smooth, matt surface.

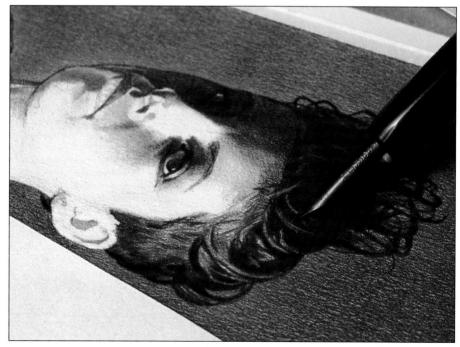

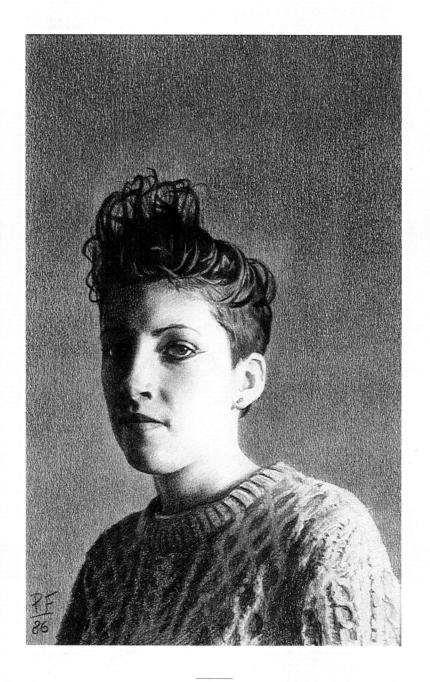

Tricia

9 The finished drawing is almost photographic in the rendering. While retaining the same tonal values as the original black and white print the coloured version explores many areas of interpretation that are completely lost in the photograph. The background has been worked across the texture of the paper very cleverly, making maximum use of the surface while the more delicate textures in the subject have remained smooth in finish. The layering of colour has built up subtleties that a camera would never find.

Alhambra Gardens

The artist was inspired by the earthenware-pink roof tiles and the reflective pale stucco of the plastered walls in this beautiful garden. She deliberately chose a pink tinted paper as a background to this study to echo the pink hues. A coloured ground not only alters the effect of the colours applied, because it shines through the translucent pigment, but it also acts as a unifying force throughout the drawing, pulling together all the elements and creating the feeling of a pink light which permeates the image. The white highlights are laid separately and are slowly worked into the blue-greys of the plastered walls. The artist substantiates the pink light by treating the buildings and the foliage separately, maintaining a tight control over the show-through in each area and leaving the viewer in the cool grey shadows with a beautiful view of a warm pink world beyond.

1 On pink tinted paper, *left*, the artist first roughs in the basic shapes and areas of her composition as both a compositional and tonal guideline. These colours will form an almost monotone background to the brightness of the sunlit garden.

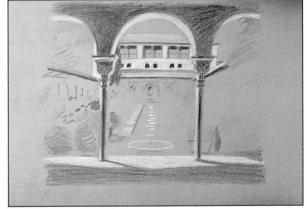

2 White is laid over the highlight areas and contrasts strongly with the deep blue shadows, conveying the brilliance of the sunshine. Where the white is fused with the blue, gentle tonal gradations are created, *left*.

3 A framework of shadow and light is developed, in which the focal points and the basic perspective are sketched. The simple shapes and colours emphasize the positive and negative elements of the image, *above*.

- 4 Dark blue and yellow basic leaf shapes are crayoned in, *far left*, to be mixed with various shades of green later. The blue will darken the green in areas and the yellow will give the impression of light-struck leaves, enlivening the foliage.
- **5** Having drawn in the coloured foliage, shadows are reworked in deep hues, *left*, to give the leaves and flowers dimension and form.
- 6 The final drawing successfully combines restrained colour and the exaggerated effects of light. The pink of the paper is carried through in the terracotta tiles, and the dappled shadows across the path in the foreground, and contrasts with the bleaching effect of the harsh light. Once the style of treating highlights and shadows had been decided upon the work developed as a series of patterns of dark and light areas and is quite systematic in its approach.

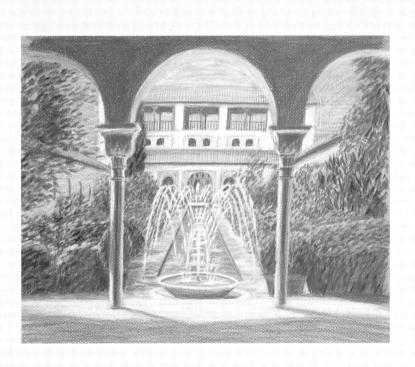

Alhambra Gardens

Fairground

The graphic qualities of the huge inflatable fairground clown and the textures and surfaces captured in the reference photograph suggest a stylized treatment which is both smooth in texture and accurate in description. The artist has carefully mapped out the whole work and has transferred it to the drawing surface line by line. Because he decided to follow the colours of the photograph it was not necessary to build up the pigment in soft inter-relating layers. Colour was therefore applied very positively inch by inch from the top of the work downwards. However, by treating the major areas of colour first the artist has allowed some freedom for specific colour reference and adjustment. The colours of the figures have been kept purposefully softer than the background to give contrast, particularly in the fabrics, where highlights have been reinstated.

1 The wonderful juxtaposition of bright primary colours in this photograph of a fairground, *right*, struck the artist as an interesting subject to draw. She used the photograph as a reference for the image which she first drew onto iron-oxide paper. She then retraced the image onto the drawing surface using a conté retracing sheet.

2 The artist gently lays areas of watercolour pigment, dotted around the image as a guide to the colour composition. She now smooths and softens the pigment with a damp piece of rolled tissue paper – an improvised tortillon, below left.

3 Colour is applied to all areas of the picture, in controlled patches, the background being worked up to an almost complete state before the figure receives its finishing touches, *right*.

- 4 The areas of highlight on the sleeve of the girl's cardigan were created by laying the pigments very lightly, leaving plenty of white showing through. Then using a soft putty rubber the colour was blended very gradually into the paper's surface to achieve a delicate tonal range, right.
- **5** The artist has chosen to work from the top of the picture downwards, partly for colour control and partly because the drawing was large. It was supported on a drawing board and, since she was working from the top down, it enabled her to use heavy colour without constantly having to lean on the picture and possibly smudging the colour, *far right*.

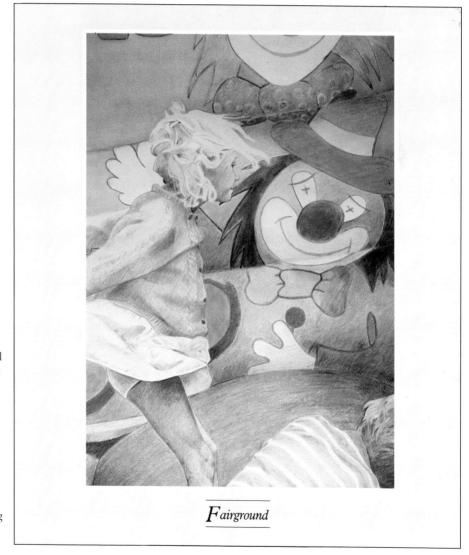

6 The tonal range of the original photograph is quite narrow and the artist has emulated this in the finished image while working in a far lighter, more delicate band of colour. This decision dictated a stylistic treatment in sympathy with the airiness of the inflatable toys and the light sensation of the children jumping. The combination of diluted and dry pigment provided an interesting variation in texture and density of colour.

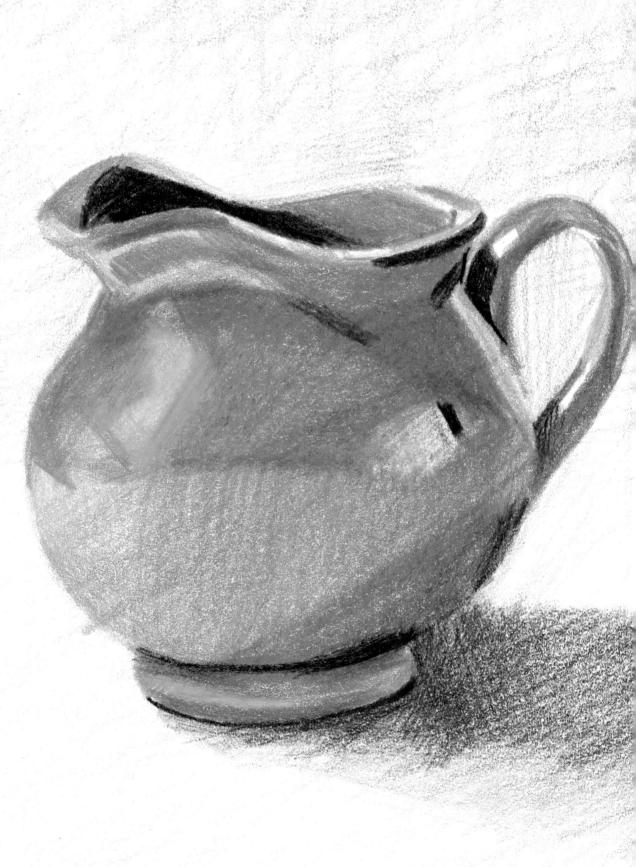

CHAPTER SEVEN

COLOUR AND FORM

Colour is a means of giving form to objects in terms of highlight and shadow, and it can also be used to make objects 'advance' or 'recede', thus suggesting space and dimensions within the picture surface. Colour has many associations in our minds too, with certain colours suggesting certain sizes, shapes, and even tastes and smells. For instance, lemon yellow immediately suggests the fruit, so that the colour takes on its own form in our minds. Such associations can be used by the artist to give particular meanings to colours and shapes.

THE STRUCTURE OF COLOUR

The colour you see in an object is not a flat tone, it is a combination of several colours juxtaposed and interacting with each other. Look at an object carefully, say a white coffee cup. If you study the different parts of it closely you will see not just white and grey, but yellows, blues and even pinks. An object coloured with little tonal variation does not convey as much sense of form as one in which the tones are heightened. We therefore need colour to see form.

Any shape you see is a shape of colour, created by diffuse colour and, therefore, shape. that colour - it is not simply an outline which is 'coloured in'. Without drawing in outlines it is possible contain just as much colour as areas which are less

to construct a coloured object which looks realistic.

LIGHT AND FORM

While flat areas of colour do not themselves usually create or delineate form, the fall of light on colour certainly helps to create the illusion of shape, or indeed to substantiate the shape of a form already suggested to the eye. A single strong beam of light has potential to describe form because it produces exaggerated lights and darks, whereas a more even blanket of light tends to

Highlights may appear white, but in reality they

Colour-form association

Cultural associations of colour make us see a certain object in a certain colour and we find it hard to visualize the same object in a different colour. These associations apply to the shape of the colour as well. If you think of a lemon, apart from its taste you think of lemon vellow and its oval shape. But

when you visualize an oak tree vou do not associate its shape with lemon yellow. However, by colouring it as such you change its context - for example you may use this colour to exaggerate the notion that it is autumn.

illuminated. If you look closely, you will see that the illuminated patch takes on colour from the colour around it and from the light projected onto it. As the shape of an object recedes it moves away from the light source and as the level of illumination decreases an area of shade develops. Even this area, seen crudely in our minds as grey, contains shades of the colour around it.

You can use the elementary observation of light and dark to achieve great effects of a three-dimensional quality within your work by pulling colour forward where the lit area appears to be highly illuminated and pushing it back where the light is less intense. Paler colour will have greater definition in the foreground,

but placed far back in a work will become so muted as to appear lost. Bright colours jump forward and darker colours recede, because in simple terms bright means well-lit and implies the foreground, and dark means under-lit and suggests the background. You can therefore exaggerate natural colours in order to create a greater sense of form than might be achieved if strict colour compatibility of the visual and the drawn were adhered to.

Colour-form association

The same colour-form associations apply in the example above as for the lemon and the lemon-coloured oak tree on the left. The colour orange conjures up the fruit, as shape and taste; it does not suggest a cube. You could argue that by colouring a cube orange, you give it a connotation of

freshness and even a taste, a concept much used in advertising and packaging.

Colour in light and shadow

Colour is apparent in areas of both highlight and shadow. The jug, below, illustrates illuminated colour and shadow colour. Right, the darker colours imply areas of the form that move back in space, and the

lighter colours those that reflect light or that are closer to the foreground.

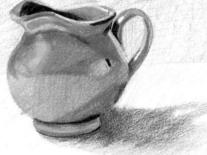

Highlights in the jug handle, below left, range from black to white and from orange to deep red. These colours are the tones that the eye perceives although we know that the jug is really only one colour. The shadow cast by the jug below is colourful despite the fact that it receives little light.

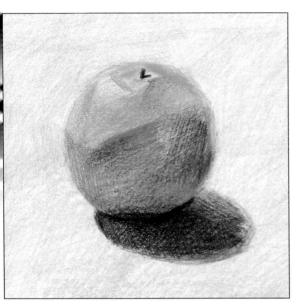

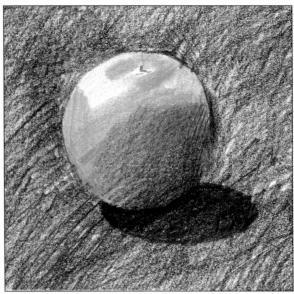

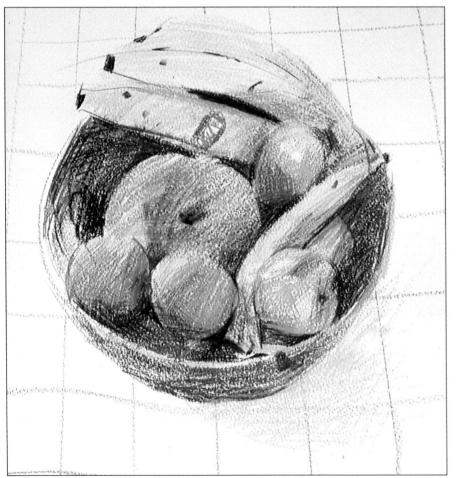

Juxtaposed colour Above, the yellow-green background acts as a foil to the orange, making it jump forward, whereas black kills the vibrance of the colour.

Reflected colour

Left, oranges in a bowl of fruit pick up reflected colours from the surrounding fruits and the fruit bowl. Notice how the artist has also used a deep red for shadow areas on the oranges. Although this is not a realistic interpretation – oranges do not actually contain these colours – it conveys the colour context very successfully.

Harbour

Building up layers of pigment gradually the artist has created a work based on his careful observation of colours and their patterns – rather than objects and their colours. He sees around the boats and blocks in the background, he sees into the boats and colours their depths, he sees highlights and burnishes in around them. Above all the image is a vision of shapes with colour which, when completed, suggest colours with form. Unhampered by line the artist's colours live with a structure of their own.

- 1 The artist saw this harbour scene as a series of colour patches and shapes. In his sketch, *right*, he first worked out the skeleton of the composition in lines of French grey and then noted down briefly the relationship of the colours and their forms.
- 2 The shapes of the boats and the surrounding landscape have been worked up as areas of flat tone with strong directional lines, *far right*. Each colour has been related to its neighbour and has been used as a foundation from which to build up further layers of colour. The pink of the bluff in the background echoes the pinkpurple of the boat on the right of the picture.

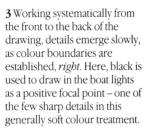

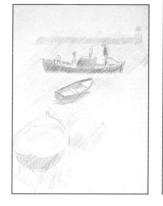

4 The background and horizon have been kept very soft and misty purposely to emphasize distance – sharper detail would have pulled them forward too far, *left*. Both the colours and the forms fade in a muted haze as they would in reality.

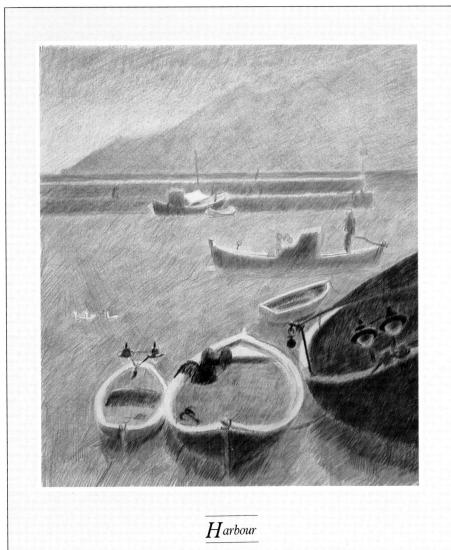

Left, the artist has used his knowledge of colour very cleverly to draw out pattern, using the negative and positive elements of the forms. For example he has left the paper white on the rims of the boats to produce a pattern of curved outlines against the inside of the boats, which have been left as flat areas without shadow or colour depth.

Eiffel Tower

The artist has created a very confident, cool and controlled study of this famous landmark. Despite the hazy monotone effects in this work it does in fact hide a wealth of colour. Gradations in hue take the eye from the foreground along the distant perspective of the tree-lined boulevard to a focal point, where, at the end of a receding row of dark trees, we are over-shadowed by the tense span of the structure's feet. Like a dinosaur it towers above with its head in the clouds. We do not see the top, it is out of the composition, there by inference only, just as the colour is hinted at – black against white, negative against positive.

1 Having worked up the sky with a loose hatching of sky blue the artist concentrates on developing the central features of the drawing, choosing to work from the focal point outwards, *right*. The dark grey silhouette of the tower stands starkly against the paler sky.

2 The dominating perspective is developed by drawing in shapes on either side of the avenue that leads the eye to the tower, below. The artist is also trying to show that lighter colours, such as blue and lilac, recede whereas dark colours come forward and thus exaggerate perspective.

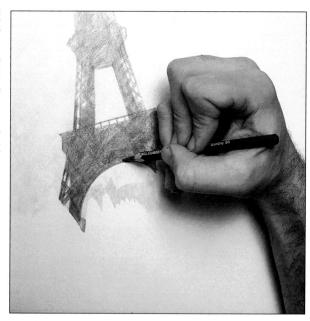

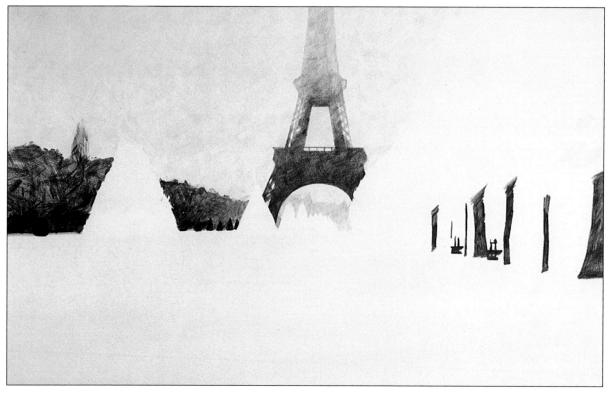

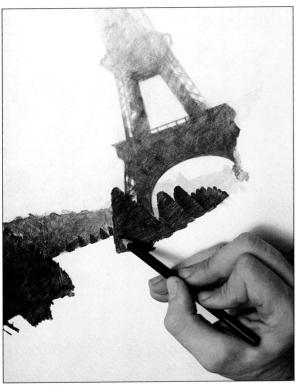

3 The highly stylized bushes beneath the tower create a balance, echoing the shape of the tower, *left*. Their dark closely worked forms, produced with heavy pencil pressure of indigo over sap green, stand proud of the loose, lighter background and create a weight in the image which takes the eye down from the towering shadow very firmly to the solid ground below.

4 Using the edge of a ruler, the artist achieves a mechanical precision in representing the manicured edge of the boulevard's grass verge, *below*. It can be helpful to use straight edges to mask an area for colouring temporarily, to allow the strokes to be drawn freely

without worrying that they will end outside the edge desired. The pencil used was sharpened to expose a considerable length of lead, allowing the artist to use rapid, broad strokes to cover a relatively large area with speed.

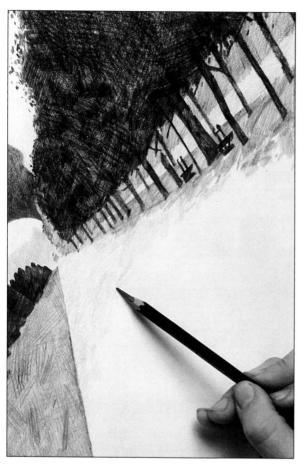

5 The very distinct areas of light and shade produce negative and positive forms. Here, *left*, colour is applied with small, delicate strokes which allow the paper to show through, and achieve a very pale tonal gradation through pressure rather than by colour mixing.

6 To soften the linear nature of the pencil strokes on the medium-grain paper, a plastic eraser has been used, *below*, to create a smooth fine colour where the light is so bright that only a hint of tone is needed. Halfway through the drawing the artist sprays on some fixative to prevent the colour from smudging.

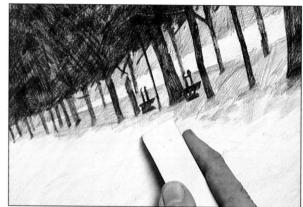

7 The colour is seen clearly here, *left*, as areas of shape, textured by the pressure of the application and the direction of the strokes. Very slight changes in the flow of the lines are visible in the base of the tower, the trees and the shaped bushes.

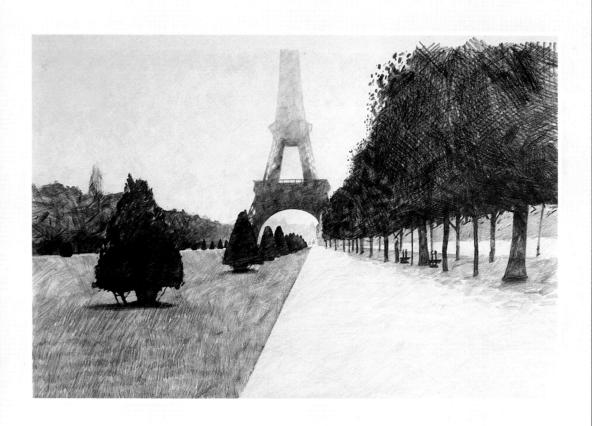

Eiffel Tower

8 A geometric organization becomes quite apparent in the finished image. The shape of the dark area of trees on the right mirrors that of the area of grass on the left. Similarly the lit area beneath the trees on the right mirrors the segment of middle distance trees on the left. The

triangles of the cypress trees emulate the triangle of the tower. All the lines converge at the right foot of the arch. Pressure, used cleverly with colour, relieve this almost monochromatic image by increasing its tonal variety.

Still Life or Magic?

The artist in this case is an amateur magician, which is why she chose these objects for her still life. She has carefully constructed this work on a skeleton of lines. Applying colours in a sequence, the image was built up to describe, in terms of colour, a world of shape. We even look at the top hat as a negative shape – from the inside out – and similarly the hat and gloves form a white silhouette against a sea of colour. The whole picture is a study in positively applied colour creating negative forms. Even the angle at which the still life is viewed extends this approach by throwing forward a very three-dimensional object from a considerably flatter background. The depth is as illusory as the trickery it depicts!

1 Using a colour that will be present in all the major elements of the drawing the artist has sketched in an underdrawing with positive lines as a skeleton on which to build colour, *right*.

2 The artist now lays in an area of green, *below*. Some black has also been used in particularly dark areas, to create a balance next to the white focal centre of the composition – the magician's glove.

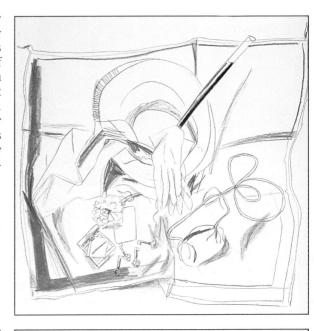

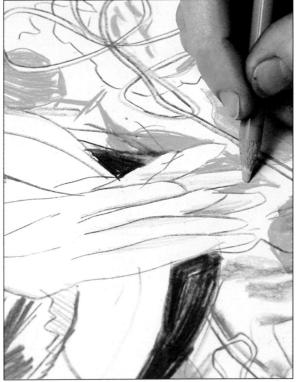

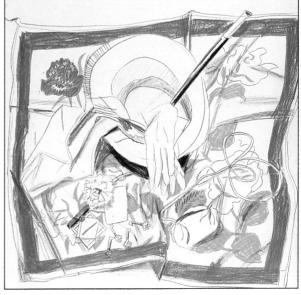

3 *Above*, two small points of red are drawn in – the tip of the wand and the fold of the scarf – to be developed later.

The red heightens its omplementary, green, as it is worked around the coloured hapes, *right*. The bold, heavy trokes give the colour a density which exaggerates the pattern and decorative qualities of the mage.

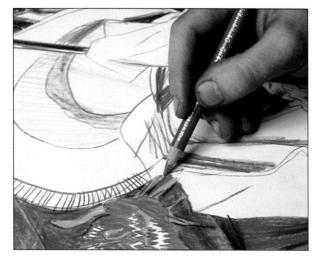

5 Only when all the elements are in place does the shape of the colours add form to the completed still life, *below*. Although shadows have been drawn in over the existing colours, the structure of the picture is still fairly flat. It relies heavily on the artist's ability to abstract colour and form to create dimensions.

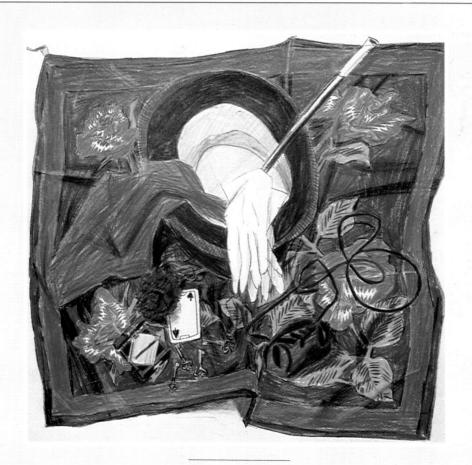

Still Life or Magic?

Beachboys

Taking a colour snapshot as reference the artist has analyzed the subject and decided to depict the scene in more sympathetic tones – in very pale, bleached colours reminiscent of bright sunlight on a hot day by the sea. The camera cannot 'quote' what was actually seen, so here the artist is giving back life and emotion to a picture which has been 'flattened'. Using transfer paper, a brief but accurate guideline was drawn onto the paper and patches of reference colours were then added

over the whole area. Very gentle strokes of pale pigments were then applied overall, particularly in and around the two figures. The artist took care to leave large areas of highlight and graded the tones very subtly into neatly defined areas of shade.

1 The over-exposed highlights in this snapshot, *above*, emphasize the brightness of the day and suggest the treatment to be used.

- **2** After sketching in an outline for the figures, *above*, the artist has roughed in areas of colour using very delicate masses of line and tone.
- 3 Since all the colours are intended to be pale it is important to maintain a very gentle touch with the pencil. The pigment quite clearly sits on the surface texture of the paper too much pressure and too heavy a colour would be deposited.

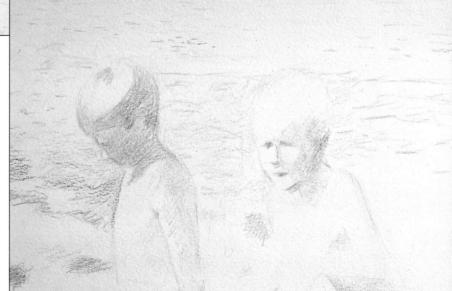

♠ The completed drawing shows just how much colour an be created and maintained within a very narrow tonal band. The secret of its success is the ery considered delicate nandling of the pencils. Note now a smooth uptake of mixed bigment is used for the flesh ones in comparison with the background where more demonstrative strokes and linework combine in the rocks and seaweed. At the first glance, this sun-bleached scene belies he wealth of colour it actually contains.

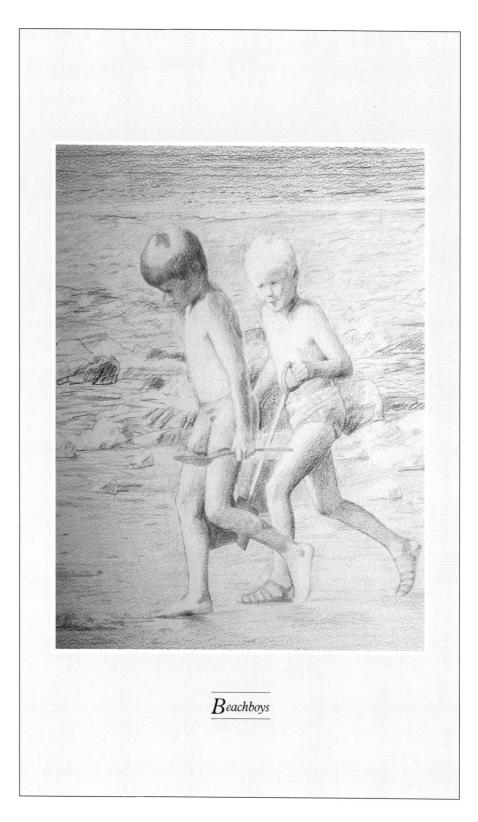

CHAPTER EIGHT

WATER-SOLUBLE PENCILS

It is true to say that all coloured pencils are soluble to some extent, as you may already know if you have ever licked coloured pencils to obtain lovely, smooth, bright colours. But some coloured pencils are deliberately manufactured to be soluble, whereas others are not intended to be used that way. Soluble pencils are marketed as water-soluble, although if you try a range of liquid solvents, from saliva to water and turpentine, a measure of liquidity will be achievable with most leads. In destroying the bonded pigment you can create a version of watercolour painting, or you can use the medium to intensify dry colour, heightening and refining the more granular effect you get with most pigment.

SUITABLE MATERIALS

Before you start painting it is important to first consider the type of paper you wish to use. There are really two alternatives - either a strong watercolour paper, which will not wrinkle when saturated, or a medium-grain drawing paper stretched on board in preparation. Watercolour paper is available in a variety of sketchbook formats, so it does have the advantage of portability particularly for quick or small-scale works. Also bear in mind that, although when drawing with dry pencil a surface texture is an advantage in that it takes up the pigment in its grain, once the pencil pigment is dissolved in water too much texture can be a positive disadvantage because it impedes the fluid quality of your liquid medium. Watercolour paper also has the advantage that it can easily be cast aside if errors are made, whereas stretched paper involves a complete day's preparation.

Caran d'Ache, Venus and Rexel all manufacture watersoluble pencils in large ranges of colours. But do experiment thoroughly before starting work because they require a much quicker method of working than dry or dampened pigments do, and mistakes are not so easily rectified. They cannot simply be rubbed out without destroying the surface of the paper, particularly if even slightly damp.

TURPENTINE

An alternative to water as a solvent is turpentine or white spirit. Turpentine will act as a blending agent on many coloured pencils, water-soluble or not. Because it is an oily liquid it produces very different effects from those of water. Close analysis of coloured pencil pigment diluted by turpentine and water will show that whereas water tends to dissolve the pigment particles to an almost powder-like fineness, turpentine floats the particles of pigment without dissolving them. It also dries very fast and is not as easily spread as water. However, if you want to dilute pigments on a dry pencil drawing in certain areas only, turpentine can be an ideal medium because it dissolves most pigments, it is easily controlled, and it dries fast without soaking and wrinkling the paper.

Alternatively, dipping the point of a tortillon into turpentine and rubbing it into areas of solid pigment

Brushes

The brushes you use with water soluble pencils, right, will affect your style and methods of working and may considerably alter the quality of dissolution, the spreading of the pigment and the resultant colour. A stiff, flat, hog-hair brush will almost grind the pigment into the paper surface and will produce very distinct strokes. A sable brush will float water over the surface delicately. Man-made fibre brushes are useful, particularly with spirit solvents, and offer a slightly more flexible control than the traditional hog-hair flats do.

will act as a good smudging agent to soften and create muted colour effects, either independently or as a blender. Turpentine and water do not mix, so if you are going to combine both techniques it is usually preferable to work the turpentine in first and flood the water over the surface later.

COLOURLESS BLENDING PENS

Many coloured marker pen systems now include colourless pens for blending their own colours. These combine surprisingly well with coloured pencils and offer very tight, precise control over blending colour, particularly in small areas. Many of these markers have strong fibrous tips which may be used as they are, or cut with scissors or a scalpel to form nib-like variations which offer a hard point capable of a variety of fine or thick strokes. These markers have an advantage over water and turpentine in that they are very transportable, they dry almost instantaneously and require no special papers. Beware of rag papers though, because they tend to soak up the chemicals these pens contain and create what is known as a 'bleed' effect, where the line appears fuzzy.

One disadvantage with blending pens is that when blending pigments the nib will pick up colour, so a constant watch has to be made to keep it clean, rubbing it off with a rag or running out the colour on scrap

Solvents

All pencil pigment is soluble to a degree. The effects of solvents on various leads do, however, differ: water dilutes watersoluble pigment very smoothly, far left, producing a solution which will dry without patches; turpentine can be used on nonsoluble leads but tends to dissolve the bonding agent in the lead and coagulate the remaining particles of pigment centre; acetone-based colourless markers, left, can be used on all coloured pencil pigment and have the advantage of drying instantly, but often leave a 'marker' effect.

paper. It is wise to carry a few of these pens and perhaps use them within certain colour ranges only. On the whole, pens dissolve pigment very thoroughly, also offering a degree of manipulation through their rigid nibs that cannot be achieved by brushwork. They present a tighter medium than watercolour but although attractive, they lack the delicate fluid nature of liquids.

EXPERIMENTING WITH WET COLOUR

Begin by laying a range of colours next to each other on a medium-grain surface, applying the colour with moderate pressure. Repeat the sequence, but using heavier pressure until the lead is almost burnished into the surface. Run a wet brush over one edge of your strips of colour and you will see that where the pigment is less dense, and with pale colours, the colour appears to spread more than pigment which is heavily laid or darker in tone.

Having analyzed pure colours, try laying some strips of pure and mixed colour, side by side. Again, these may be gradated. Run a wet brush over the point at which the strips meet to see the range of subtle colour permutations that can be achieved by blending with water. Due to the intensity of some colours, some hues will appear to have greater dimension than others. This is partly why, in water-soluble media, the palest colours

are laid first, followed by the darker colours. For the same reason it is very difficult, when working in a translucent medium, to cover one colour with another.

PAINTING WITH WATER

Having decided on the base and the pencils to be used, analyse the subject to determine the type of colour you wish to portray. You will find that you have to think in much the same way that a watercolour artist would, seeing the image as a collection of fluid tones and colours rather than as a pencilled 'structure'.

Having determined your 'map' of colours it is important to consider how and in which order to apply your colours. Colour laid in suspension is not 'solid', like dry pigment, but translucent, like watercolour – it is therefore possible to create very subtle colour structures by overlaying tones. Building up from light to dark you can lay down one colour, allow it to dry, and float another colour over the top of it, gradually constructing a sense of density and dimension within the coloured area.

Generally, as in watercolour painting, it helps to block in the pale colours first and continue to leave the darkest areas till last. But with pencil drawing it is slightly different in that you are applying the colour with the pencil and using water as a blending agent. This means that although your pigment may eventually be softened and made more fluid, initially it is applied

'neat'. Obviously, when using a brush it will help to apply the pigment softly and not ingrain it too much into the paper. But having said that, the more pigment that is applied, the greater its spread will be and the greater the scope for creating wide scales of intensity from highly-saturated to highly-diluted colours.

It may help to keep a jar of water next to you for painting large areas and for brush cleaning, as well as a water-soaked rag in which to press the point of the pencil to dampen it. Applying a wet pencil point will create areas of easily worked pure pigment. This is easier than trying to spread dry pigment, which will be less concentrated. Using water on pencil will provide reasonably quick results, but do remember that each move must be fully considered, as must how much pigment to apply, how much water, which brush to use

and how to move it, because water dries quite slowly and will need to be under your control.

WET AND DRY PENCIL

In many drawings you may wish to make a combination of water-dissolved colour and dry pigment. This can be very effective when the dry colour is added over a dissolved base, but remember to let the paper dry sufficiently or it will not only moisten the pencil point and produce an inky line, but it will most probably tear the paper. Also bear in mind that when you are handling liquids, they tend to spread fast. Complete blending can, of course, be achieved with water-soluble pencils but many effects, some of a very complex nature, can be created through the combination of dry and water-soluble pigments.

The effect of water on colour

The swatches of colour *above* illustrate a basic palette of water-diluted colours. Notice how pale colours do not change as perceptibly as darker ones do. The fused bands of colour, *right*, indicate how the dissolved colours change their tones while increasing the vibrance of their hues and the subtlety of their saturation.

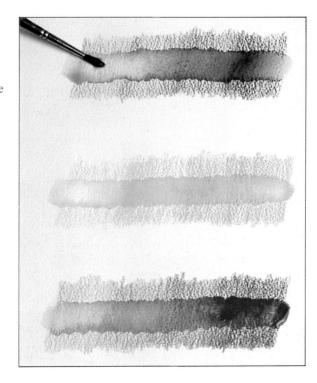

Water-soluble on dry pigment

Complex combinations of pattern and colour can be created by laying water-soluble tones under or over non-water-soluble strokes. *Above right*, a soluble ochre was floated over a non-soluble blue and red grid, to create an entirely new effect.

Fusing several colours with water

Subtle colours can be produced by overlaying numerous dry pigments and then fusing them in solution, *below right. Far right*, 12 pigments were placed adjacent to each other and were intermixed by blending them with water to produce a range of new colours. Experiment using both media by laying areas of tone and hatching in a variety of colours and running a complementary coloured wash over the top. Try also laying dry pigment in an area and running a water-soluble colour up to it. This juxtaposition will result in a great sense of texture which will offer increased scope for producing three-dimensional effects. Experiment with small sketches, drawing a simple object in dry, hard pigment and running behind it a background wash with a water-soluble pencil – the results are often very striking.

Although the blending of colour is one of the main attractions of this medium it can also prove to be a problem, particularly where highlights are concerned. Either mark the 'white' highlights very clearly and avoid them, mark them with masking fluid, or burnish in a

white area very heavily with pencil, possibly followed by a paper stump. This will to some degree take on the effect of a wax resist which can be softened at the edge later with some delicate brushwork.

It is often handy to keep tissue with you to soak up unwanted water on the work or to take excess 'paint' out of the brush between the application of colours. A large sable brush will perform this function, as well as enabling you to push pigment around over big areas, in conjunction with a finer, stiffer brush for small details.

Finally, it is worth mentioning that successful effects may be obtained with both dry and wet mediums by blending colours already laid down by burnishing over them with a moistened white pencil.

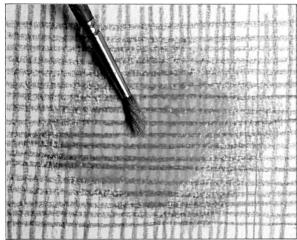

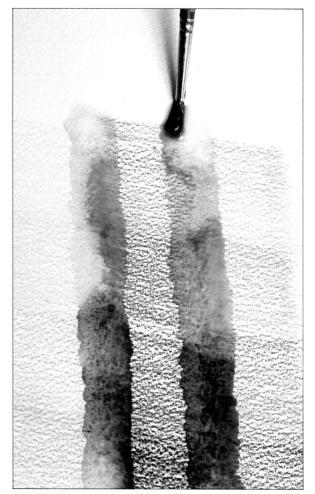

Water-soluble compared with dry pigment

Because coloured pencil pigment is, to a degree, translucent in its dry state, it seems natural to explore this quality further by dissolving it. Once diluted the colour changes completely: its suspension over a large area makes it thinner and allows light to bounce back from the white support. The tonal variation achievable with dissolved pigment is also quite different from its dry counterpart. The sample swatches of colour, right, show a range of water-soluble coloured pencil pigments compared with dry pigment.

Try laying a strip of tone in dry pigment with an even, tonal gradation (produced by layering rather than through pressure), using the side of your pencil over a grainy paper, below left. Then run a brush of water through the centre of this band. A change in colour will result as the texture of the dry surface is lost and the paper reflects through the colour, below right.

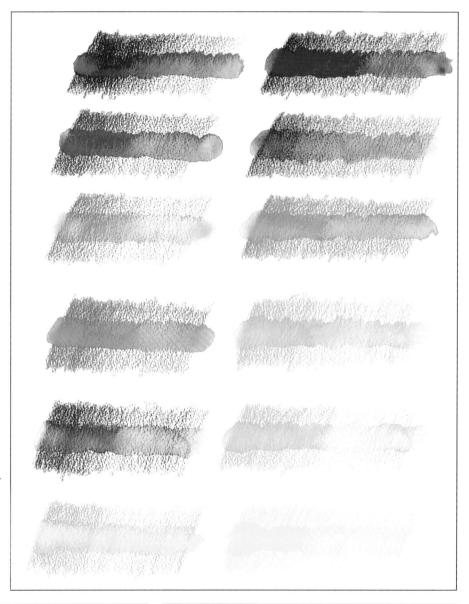

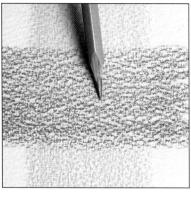

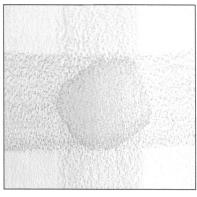

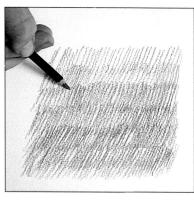

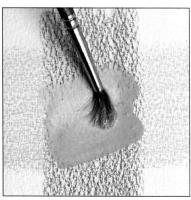

Dry and wet pigment

Colour tests with dry and wet watercolour pencils will help you to establish the colour capabilities of different pigments in solution. *Top*, two colours are laid one on top of the other, and fused with a brush loaded with water, *above centre*. The result, *above*, is a new colour, quite unlike the dry pigment in its tonal value and effect.

In the yellow and green swatch, *top*, the yellow dominates once the colours have been diluted. Similarly, in the blue and red swatch, *centre*, red becomes dominant. In the red and green swatch, *above*, the two colours combine to produce black.

Very strong textures may be produced by combining the characteristics of non-water-soluble and water-soluble pencils. Water-soluble sap green was layered with olive green and indigo, *top*. Water was floated over the surface, dissolving the sap green to produce a wash over the darker colours, *centre*. The result is a new level of colour within the texture, *above*.

Ranunculus

Planes of light and dark colour within the seemingly crushed petals of a vase of Ranunculus inspired the artist to investigate their colour and structure. Starting with one flowerhead the composition was developed in an almost circular fashion, relating each colour to the last, then the vase was blocked in and, finally, an independent background. The pigments were purposefully applied in saturated and less saturated planes. White patches were allowed to show through from the paper beneath so that later, when water was applied to the surrounding pigment, the white could carry the diluted pigment and reflect through it, giving it a translucence. Each element was treated separately until the grey colour was laid as a backdrop. The artist then took a sable brush and worked over certain features of the drawing with water. First, the background was 'washed' to create a soft watercoloured effect and a key for further treatment. Then specific areas were reworked with the brush to create new levels of intensity and texture. At the same time the pigments were blended to develop a glaze and a depth in the hues of the petals.

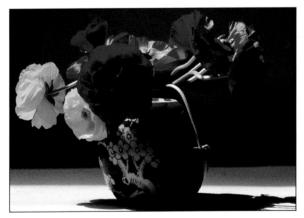

3 Black is used for the very dark tones on the yellow and red flowers, *right*, overlaid with dark carmine on the red petals. The colour is deliberately applied heavily so that when water is laid on later, the surface will not be destroyed.

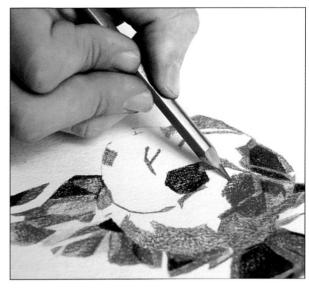

1 The brilliant colours of these full-blown flowers sitting in the ginger jar, *left*, inspired the artist to capture them in a drawing.

2 After sketching in the position of the still life with an HB pencil the artist used dark carmine, black and pale geranium lake watercolour pencil, applied with small hatched strokes, to build up the colour fairly heavily, *above*.

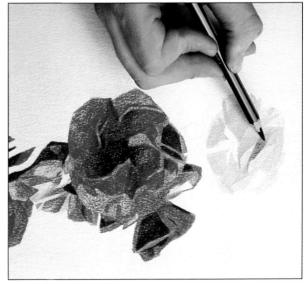

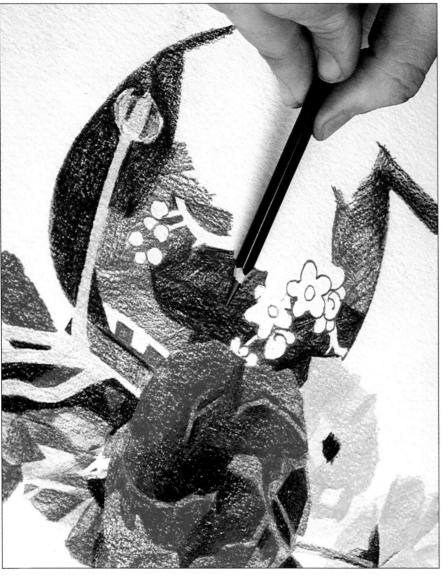

4 Here, *left*, the artist is using black for the dark shades of the vase as well, but applied with very loose strokes compared with the tightness of the flowers. Although the pencil marks will disappear when water is brushed onto the colour, the different approaches will create interesting tonal variations.

5 Below left, loosely scribbled strokes of black in the background give texture to the flat surface.

6 Below right, the drawing shows up the texture created by the pencil marks and the different densities of colour used by the artist. He decides not to leave it like this, however, but to add water to the colour.

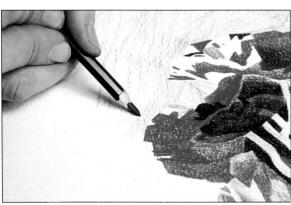

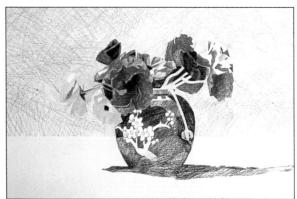

7 A sable brush well loaded with water is applied to the background area, *left*, blending the pencil marks and creating a smoother texture.

8 Water is also added to some of the petals, refining the colour and creating an attractive wash effect, *below*.

9 The vase receives the same wash treatment with a wet brush, the watercolour from the shadow areas being dragged across the white flowers on the vase, bringing them too into shadow *right*.

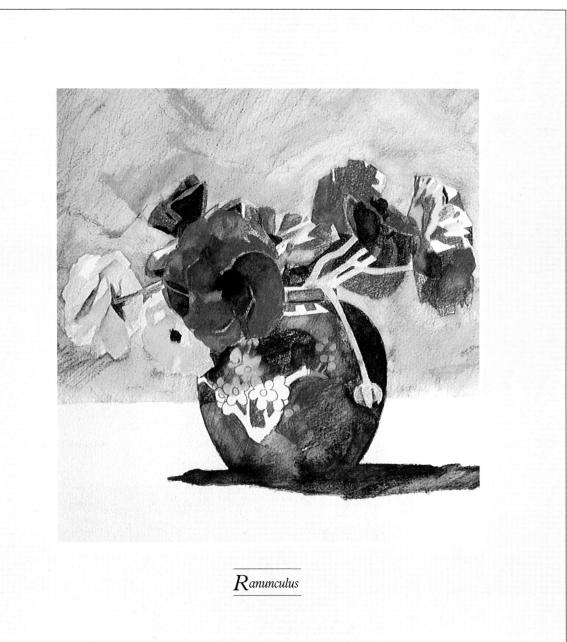

10 In the finished image the colour of the flowers is strengthened by the slightly darker background created by blending the greys. The artist has not applied watercolour to

all the coloured areas, achieving a balance in texture and finish. Caran d'Ache and Faber Castell pencils were used on stretched Bockingford paper.

Reflection

The suffused light and the reflection of the nude in her dressing glass suggested to the artist that he should treat the scene in a way that conveyed a sense of airiness. He laid down guidelines with broad sketchlike strokes at the centre of the image area and then proceeded to block in areas of colour around the focal point of the work. Using the pencil in an underhand position he made long sweeping movements to create a fluidity in the line which exudes an air of freedom. Colours are constructed as areas of linear tone, building up zones of light and shade and at the same time exaggerating the highlights and shadows. Leaving plenty of white show-through from the paper the artist has, as a final touch, taken a sable brush loaded with water to work over small areas of the drawing. In this way he has destroyed lines to create deep pools of pigments which intensify the depths of the shadows.

1 Using simple, broad, underhand strokes, the artist sketches the main colours of the composition into place, *left*. He sees the figure as a series of facets of colour and light and so decides to treat it in planes of pigment balanced by the smooth oval of the mirror and the table.

2 The pigment is laid thinly in preparation both for adding further colour and for using water to dilute the colour over a wider area, *right*.

3 The colours of the composition are strongly planted on the right, leaving the pale reflective surfaces of the mirror and table clear, *below*.

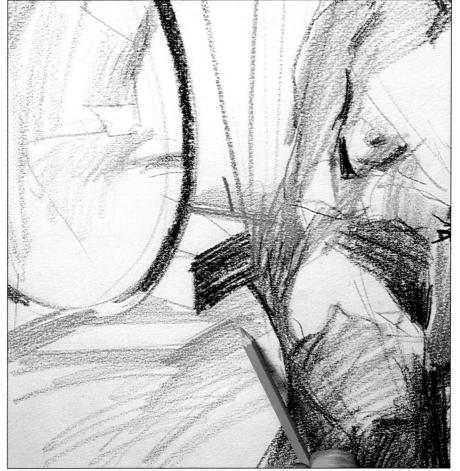

- **4** Above left, with broad strokes of the pencil, applied overhand, and using the side of the pencil point, the artist lays different colours over each other, mixing in areas of shadow.
- **5** With greater pressure and control the artist works the colour firmly into the existing pigment in the mirror area, strengthening and darkening it, *above*.

6 Taking a sable brush loaded with water, the artist dissolves the surface pigment of the mirror, floating the colour over a broader area, mixing and diluting it to achieve a watery reflective image, *left*.

Water-soluble pencils

7 Relatively small deposits of colour can be diluted to spread over a wide area. Here, *right*, one small pencil stroke of pigment is floated over a comparatively large area of shadow with a single brush movement. The effect is pleasing but the artist has taken great care to fuse only those colours that he wishes to mix.

8 Using the side of the brush the artist floats a couple of lines of blue pigment over a large area, mixing them subtly with black and umber to create a greyish cast, *below*.

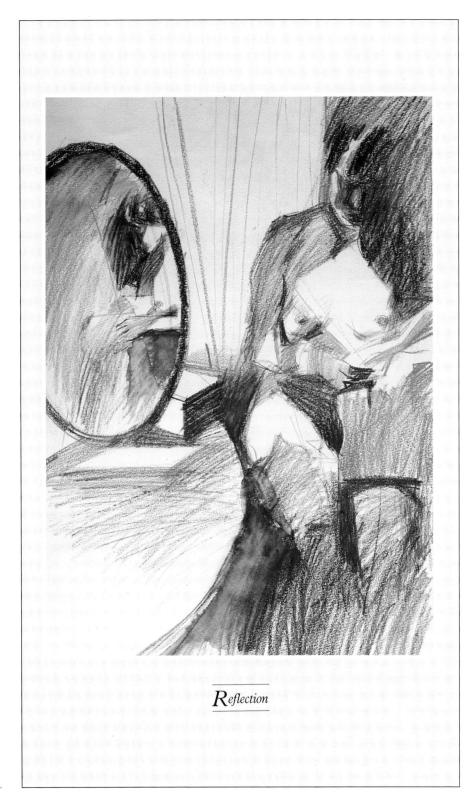

The diluted areas of pigment behave just like watercolour paints but are more grainy in substance, depositing a hard edge of accumulated pigment, *left*.

10 The watery qualities added to this sketchy drawing have been created with sparing use of water, adding a new dimension to the mixing of colours and a more solid structure to the loose linework.

CHAPTER NINE

SGRAFFITO

Sgraffito is the eighteenth-century word to describe an artistic treatment that has been in existence since the earliest efforts to communicate through drawing. It refers to the incising, or scratching of lines into a surface, often taking the form of cutting through lavers of colour to reveal others beneath. It was a very popular practice among the ancient Romans who layered pigmented plaster on the walls of their villas and then carved lines through it to reveal the stratum of colours underneath. Many fine examples of these wall 'etchings' still survive in the ruins of Rome and Pompeii. The technique has always been much used in the ceramics industry, where designs are cut through coloured slips and glazes for the decoration of pottery, but it is also popular with artists working in a wide variety of media. In coloured pencil work, cut lines can achieve some unexpected and fascinating results.

When you are creating a drawing, there are a number of ways in which you can create surface texture in the work. As with burnishing techniques it is possible to alter the surface finish and, indeed, colour of a drawing, by working over the entire surface, or on an area of a specific subject, and may be of a decorative significance rather than of direct relevance to the content of the composition. Texture on the image is an added dimension, equal in importance to the texture of the paper used, the texture of the coloured pencil lead and the texture depicted. Sgraffito can be either incorporated early in the laying of colours, or used as a finishing technique.

CHOOSING YOUR PAPER

It is important to consider carefully the type of line you want to create on the surface of your drawing, because once the surface is scratched off it is very difficult to cover up mistakes with further layers of pigment. At the outset you must also think about the effect you need because the type of paper you use will have to withstand any bladework necessary. A very soft or highly textured surface, for example, will not respond well to sgraffito and tends to tear under pressure; removing layers of pigment with the side of a razor blade, for instance, may cause thin papers to wrinkle, so try out a range of strong materials such as CS10 surfaced board, or heavier, Cold Pressed finishes, like fashion boards. Papers of a surface quality similar to boards are equally good but don't forget that in order to remove pigment in any quantity you will probably have to lay the pigment down very heavily, which may cause the paper to buckle.

A support with a 'china' surface, a surface which is removable, is best for this technique or, alternatively, prepare your own gesso boards. Gesso or plaster of Paris are easily obtained at art shops and can be quickly applied to a board with a wide brush. They respond well as a base to coloured pencil and interesting effects can be developed while the surface is setting. It hardens within minutes to provide instant texture. Also try soaking paper (as you would when stretching it) in a tray of plaster and, after taping its edges to a board, allow it to dry overnight. This treatment will provide a smooth impregnated plaster surface which has to be handled very carefully.

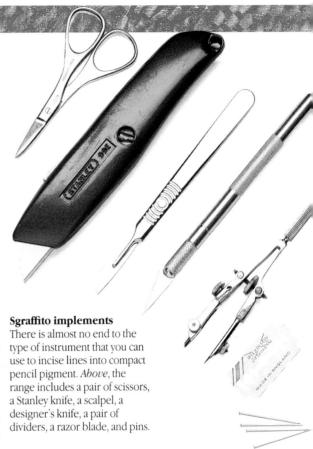

THE TOOLS AND THEIR MARKS

Practise laying down heavy amounts of coloured pencil pigment on these varying rough and smooth surfaces, using a number of mixed colours, and experiment with layering the colour, applying the lightest tone first and finishing with a dark top coat, and vice versa. Then practise removing the pigment with different sharp tools without cutting into the base. This is easier said than done and will take a considerable amount of patience to avoid damaging the paper surface. The type of instrument used to create the scratchlike marks, and the way and angle in which the instrument is held, will determine both the style of the mark and the ease with which it is made.

Virtually any metal object will do to make these marks, from pins to razor blades, scalpels and craft knives. In fact you will need only one tool to create a complete range of marks; most blades, for example, offer fine points as well as long, flat cutting surfaces. The

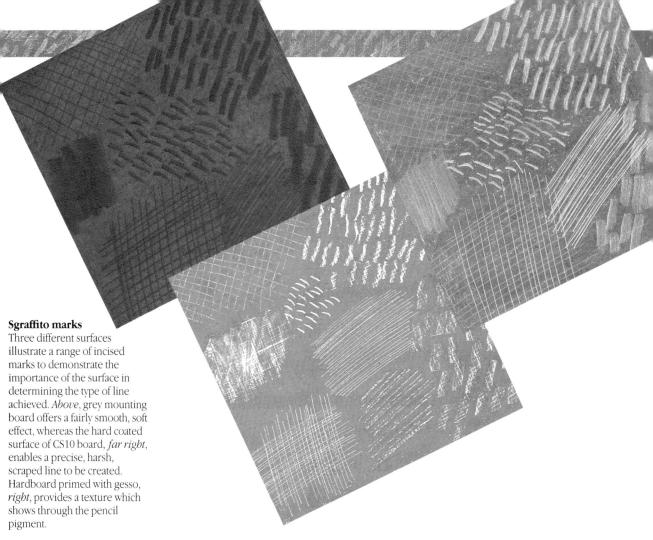

variety of effects achievable is limited only by the qualities of line and scrape that you can create with your implements.

Cutting through a dark colour to reveal lighter colours beneath will give an etched effect and can offer a precision in depicting very fine coloured lines that is unmatched by any other method. Surface patterns from fine pin-pricks through to soft graded scrapes of colour – and surface textures, may be developed to add dimension to otherwise flat colour. Try using a long scalpel blade (which will bend fairly easily) to pick into the surface, creating sharp, pointed, little marks. Then use the side of the blade or a mounted razor blade to sweep across an area of coloured pigment, removing a fine, coloured 'dust' very gradually to reveal the layers beneath. You will be able to create very smooth pale hues by removing concentrated pigment in this way the knife edge not only takes off the excess colour particles but also, by means of pressure, refines and blends what remains.

It is also possible to increase the subtlety of blended colours by using the knife actions of sgraffito to mix the pigments further as they are scraped together, carrying the colour right into the surface of the paper. It must be remembered, however, that in using such pressure the surface of the paper will become indelibly tainted with pigment and if you scratch right down to the surface of the paper it will always look tainted and not 'white'. Even so, you can achieve quite an effective 'white' patterning this way – it will not be pure white but will take on a hue from, and blend subtly with, the tone out of which it is cut.

Sgraffito is an excellent method of creating dimension, be it for surface pattern generally, or specific areas of a coloured pencil drawing. It is certainly a technique of reduction, where less becomes more. Remember that its success lies in you thinking in reverse, building up coloured layers in the order of their removal.

Paper surface and pigment density

The surface of the paper and the density and thickness of the pencil pigment are of great importance in the end result of a sgraffito drawing, *right*. The quality and definition of the line, whether it is a short, 'picked' stroke, a hatched or cross-hatched line or a long fine cut, are greatly enhanced or reduced by these two factors.

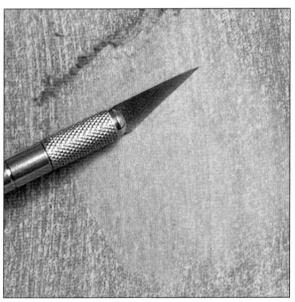

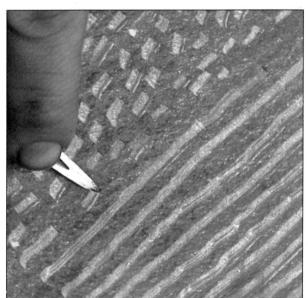

Different sgraffito marks

Above, the artist uses a designer's knife blade at a shallow angle, with very gentle but even pressure, on an area of red pigment. The blade removes the colour, at the same time grinding and compressing the remaining pigment into the surface of the paper, which itself becomes flattened through this

action and takes on a smooth finish.

Here, *above*, the artist uses a blade of a small penknife, at different angles and with different movements to show the variety of patterns that can be made using one blade only. Stippled patches can be created using the flat of a blade to scrape the colour with short strokes in random directions. Heavy striations are produced

when the blade is dragged across the colour with long strokes.

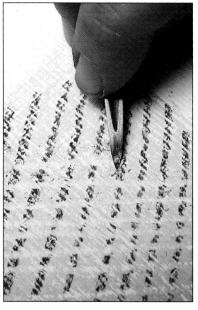

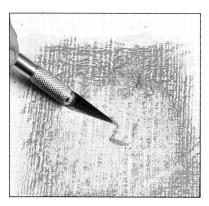

Colour and sgraffito

Left, yellow and green were laid onto a gesso-covered board and scraped with a knife blade to create a third colour in this chequered pattern. Above, red pigment laid over yellow is removed to create an orange-yellow.

Sgraffito effects

Below, far left, fine hatching was scratched in one direction, to break down the vertical texture imposed by the dried gesso. Below centre, the side of a knife blade was used with short, fast strokes, adding to the coarse texture of the surface. Below, finely crosshatched lines are spaced increasingly wider, implying an advancing curve where the grid squares are largest, and a receding curve where they are smaller. Bottom, far left, a top colour is removed carefully. The scraped area glows through, and is lifted out of the background space. Bottom centre, texture can be heightened by hatching lines in one direction over a different colour, and then scratching across the hatching in the opposite direction. Bottom, two colours have been applied diagonally in short strokes, on a coloured base, and the scratch marks have been made in a vertical direction

Palm

Just as the leaves of a palm tree grow one out of another so too do the colours in this composition. Having laid a skeletal structure in white, the artist proceeded to build up the stylishly abstract colours on top of each other to develop a variety of colours while maintaining their harmony. As the layers thickened they were scratched away with a designer's knife to create a strong pattern reminiscent of the very pronounced veins of palm leaves. Some colours were cut through, leaving a hint of their depths, others were reworked with different pigments in a gradual process of reduction and layering.

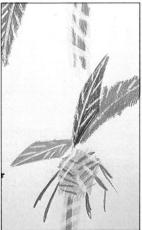

1 A sample range of colours was tried out in the preliminary sketch to work out which would respond best to the sgraffito, *left*.

3 Using pigment sticks, which create layers of thick colour, the shapes of the leaves were blocked in with strong primary and secondary colours, *right*. The pigment sticks cover the earlier burnishing but leave the veins just visible. Their width makes it possible to cover large areas quickly with a few simple, broad strokes.

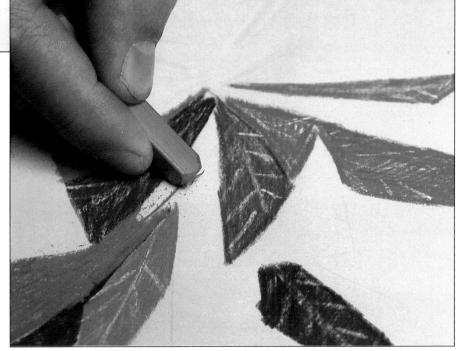

4 Although pigment sticks have many advantages, coloured pencils do offer greater control to the artist. Here they are used in conjunction with sticks to neaten edges and provide a smooth finish in contrast with the rough, textured surface made by the sticks, Light colours are chosen – blues, pinks and yellow – to contrast with the dominant, solid, more heavily saturated colours, and help to give the image three-dimensionality.

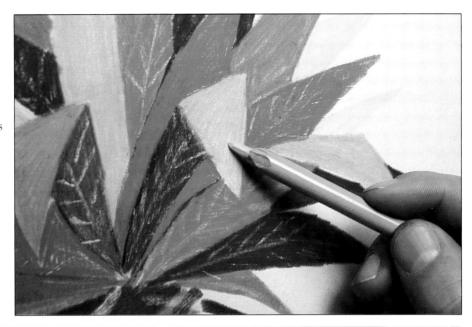

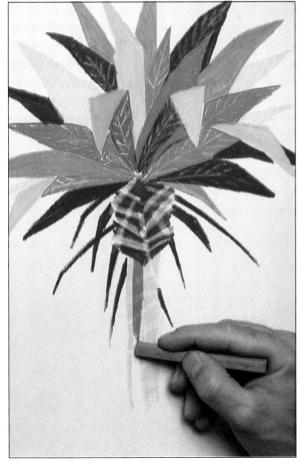

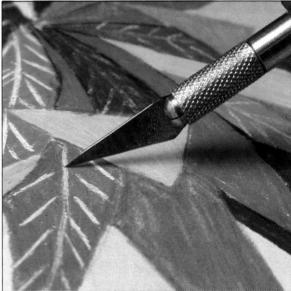

5 The colours of the leaves have been balanced over the centre of the composition but the density and weight of the leaf composition make the image feel top-heavy, so the artist adds a stem to create a better sense of distribution, *left*.

6 A designer's knife blade was used to scratch though the layers of thick colour to reveal the white pencil lines beneath. The underlying white pencil enables the artist to scratch away the colour without scraping the paper surface beneath it, *above*.

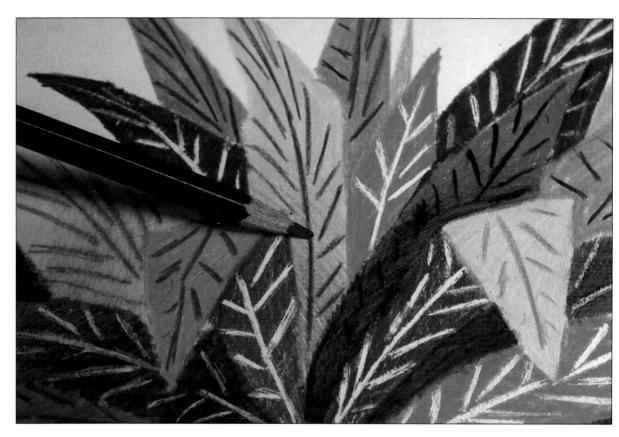

7 A layer of colour is added to the incised areas of the leaves, giving them a decorative appearance, and blue is used to create shadows in the deeper parts of the leaves, increasing their sense of dimension, above. **8** Yellow is added to the remaining white veins, lending warmth to the leaves, *right*. In some cases layers of different colours have been applied in the scraped out areas, creating a lively mixture of colour which blends optically. Streaks of white are left uncoloured to indicate highlights.

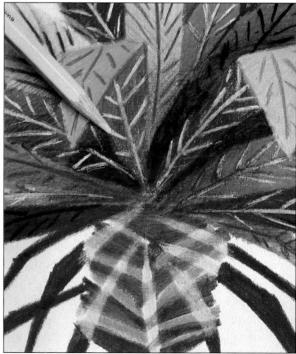

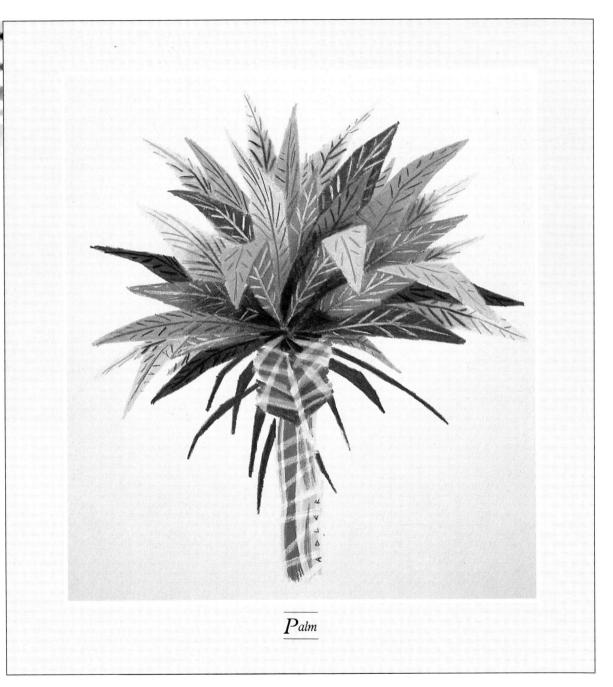

9 The finished drawing represents a very stylish approach to shape and pattern. Veining on the leaves in dark blue, pale blue, yellow, orange and white, serves to suggest reality in an abstract way. The point at which the trunk and leaves meet in a maze of criss-crossed light patterns created not by adding colour but by subtracting it, showing just how effectively sgraffito can be used to give depth to colours.

CHAPTER TEN

BURNISHING

Burnishing is a surface technique used to create added dimension to a work both in terms of finish and colour. It is a method of blending colour through pressure, and in its simplest form may be the result of fusing two colours by rubbing steadily over them with a tortillon, or paper stump, until they are literally ground down. This technique relies on reducing the pigment particles deposited on the paper to a fine grain and pushing them into the surface texture, resulting in a smooth, almost shiny finish. Because it does impart a gloss to the surface of the drawing it is often used to finish details which are shiny in character or to draw objects made from reflective materials, such as metal or ceramics.

Burnishing with coloured pencils is often more successful when carried out with a white or pale grey pencil. Moving a pencil vigorously back and forth over coloured areas burnishes in the pigments, allowing the colour itself to be altered. At the same time it offers a method with which to create very precise blending in controllable areas. Burnishing can also be very effective in producing highlight effects by giving an edge to an area of matt surface.

Experiment with swatches of colour, both pure and mixed, to test burnishing with a tortillon, or a white or grey pencil. Alternatively, if a very soft, coloured pencil is used, a similar effect can be achieved using an eraser over the pencilled surface, although this will tend to produce a more smudged effect. A drawback in using an eraser in this way is that it quickly becomes con-

taminated with the excess pigment that it picks up and unless you rub off the pigment on the eraser, its use on other areas of the drawing is restricted.

Burnishing is particularly effective over areas of gradated tone and where areas of white are to be bordered by colour, as in reflections. Look at shiny objects and concentrate on their highlights. Working from this point outwards add colour and shape. Once you have laid the basic pigment, again, working from the highlight area, burnish gradually with short intense strokes outwards until the whole object is treated in the same way. Remember that the relatively extreme pressure that this technique requires is not really suitable for papers with a heavy surface, because the pressure will either break up the paper's finish, will wrinkle, or even tear it under such stress.

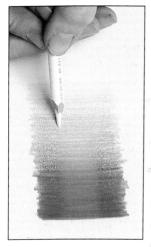

Burnishing with white

Above, the artist shows how burnishing with white can create not only a new tonal range but a new feel of colour over one base pigment. The effect of the white is seen most clearly where little or no paper shows through. The ability of white to blend or change colours when burnished on top of them is quite apparent when seen over a range of pigments, far right.

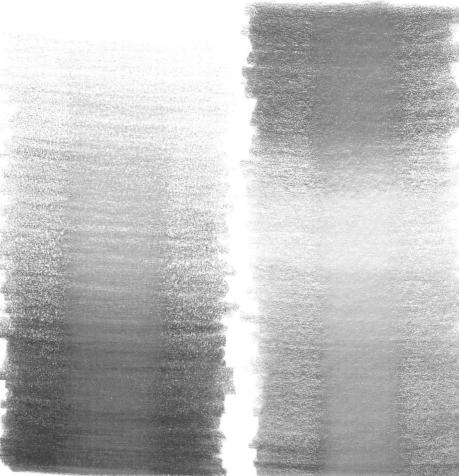

Burnishing implements
The examples, *left*, show the different effects that a variety of burnishing implements will achieve. The tortillon, *far left*, offers a very controlled, highly pressured burnish, whereas the eraser, *left*, produces softer, smudged strokes.

Burnishing with white and rey

Most neutral colours can be burnished over other colours.

Top, white and grey are

compared on the same base

colour. White generally alters colour minimally and is therefore preferable for blending two or more pigments above.

BURNISHING WITH WHITE

Colours change when overlaid with white, and it is a useful experiment to observe the differences created when overlaying a colour with white. Laying a base of white pigment over which colour is laid will act as a reflector to the colour and will increase its intensity, whereas overlaying white on colour will tend to mute strong colours, making them 'chalky' in appearance.

Take one colour and, on a medium-grained paper, create a graded strip of tone with it, from the palest end of the scale to the darkest. Then, applying heavy pressure to a white pencil, burnish a band of white down the middle of your coloured bar. As you will see, the greatest blending with the white will take place where the colour is darkest. This is a visual effect in fact. because the white will have been laid at the same density throughout the board. Where the colour is pale, a large proportion of show-through from the white paper will occur, which will naturally dilute the effect of the added white pigment. Burnishing is usually most effective when conducted with a white pencil, particularly when it is used for highlights or to create a shiny appearance. But do also try other neutral colours for different effects - pale grey may be used if an all-over colour is desired. By burnishing over an entire drawing with pale ochre, for example, you will create an illusion of age. There are endless possibilities, though they will alter your colour balance and colour intensity of your work.

Once you have experimented with single colours, try creating a spectrum of colour and burnishing a white strip over the top of it. This will show at once the different effect that white has when overlaid on colours of differing density and hue. White will have greater impact over the darker colours than over the paler colours.

Finally, try testing the ability of your burnishing colour to blend two colours which are laid over each other. While altering the intensity of your tone and giving it a chalky nature you will see that this blending technique will in effect grind down the particles of coloured pigment, distributing them evenly and solidly onto the paper surface. It is possible to achieve very smooth and subtle colour blending through burnishing, entirely losing the granular effect of layered tone.

HIGHLIGHTING

Burnishing may be integrated into the plan of a drawing but can easily be utilized as an afterthought to highlight a particular element or introduce a new texture to the surface of the picture. It can also be used as a technique in itself to create texture, such as shiny lines over a matt surface, or glassy dots on a plain background. Taking this principle further it is possible to alter the entire nature of a flat-toned work by burnishing over the whole surface of the completed piece with a particular movement. In so doing you can create a stroke-like texture over the surface of a drawing which bears no relation to the drawing – you can literally apply a finish!

WAX BLOOM

A note of caution must be added, because a phenomenon known as 'wax bloom' may occur on heavy burnishing and it may come as quite a shock when you first see it. When you press down hard on coloured pencils the bonding agent of the pigment, which is waxy in nature, is deposited in considerable quantities on the paper surface. Once the drawing has settled, this deposit may exude a greyish haze over the surface of the paper, dulling the colour. But it can be wiped away easily, with a tissue, and if a coating of fixative is promptly applied it will seal the surface of the drawing, preventing a recurrence of the bloom.

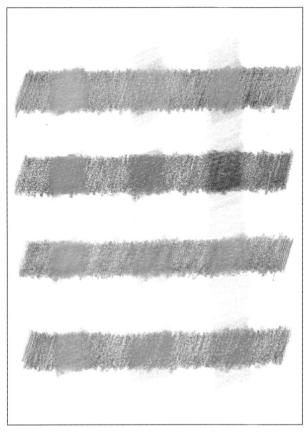

Burnishing with white, grey and ochre

The demonstration *above* shows four colours, each burnished with white, grey and ochre. Any colour, when burnished, will adopt the hue of the colour laid over it. The colours above indicate the variety of effects that these three neutral tones can create and reveal that the colour change that these tones render on one pigment is not necessarily the same when applied to other colours.

Burnish with colour

The series of swatches, *right*, demonstrate the effects of burnishing red, yellow, blue, turquoise, brown and grey, with stronger colours than white, grey and ochre. In many instances the original colour is altered completely; in others it just takes on the sheen of the overlying colour.

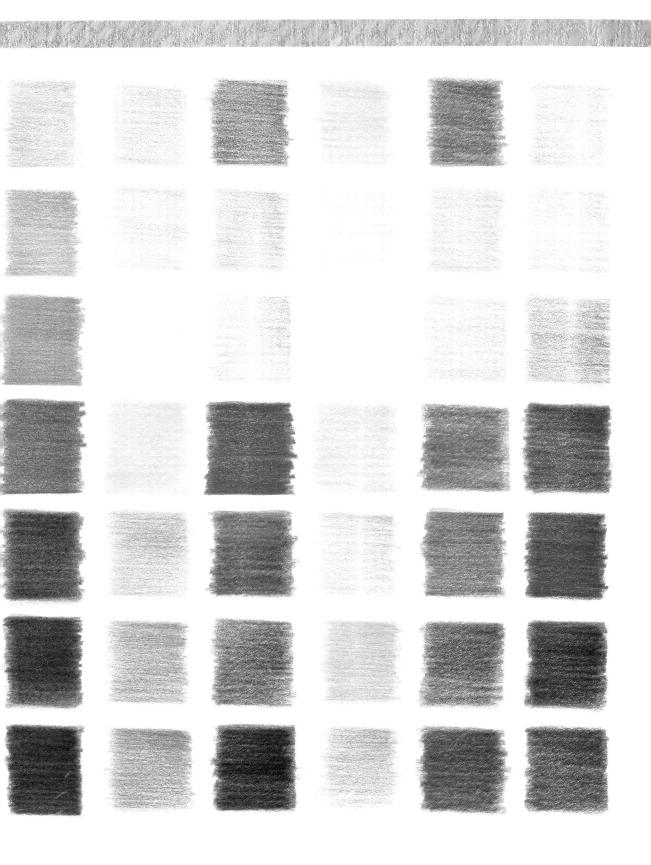

Battersea Power Station

The scene of angry workers in front of the power station conjures up an image reminiscent of factory workers and urban industrialization at the turn of the century. The artist has deliberately chosen a style which, in its human scale, its handling, colour and its imagery, emulates that of the Futurists who were painting rather similar subject matter in the early 1900s, glorifying the power of industry.

The artist has worked in a systematic fashion using a fine outline to delineate areas of colour, and has built up patches of basic lines as a foundation to the heavier layers of colour required later. He constantly used a white pencil in order to burnish highlights, such as the sheen on the workers' clothing. Exploring these effects further a typist's stencil was used as a template for burnishing colour with an eraser.

1 A couple of small pencil sketches, *above*, made during an evening walk, suggest an idea to the artist for a composition in colour, inspired by the red brick monolith.

2 Having masked off the areas of the image with masking tape, the artist sketches in the main elements with a graphite pencil and now begins to add soft base colour, *left*.

3 Laying colour quite heavily over the garments of the men at the foot of the drawing, the artist develops strong shapes and a visual story. Using a white pencil the pigment is burnished into highlight areas to create a glossy sheen on the folds of fabric and give a strong stylistic approach to the treatment of colour, right.

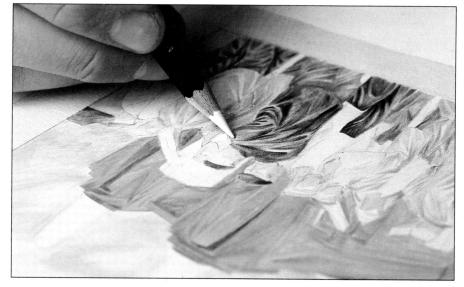

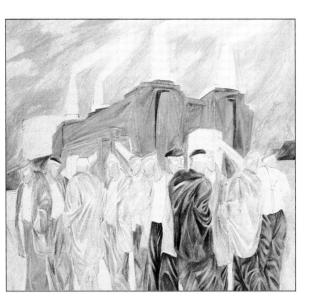

Left, all the main areas of colour are blocked in to form a foundation for deeper colours to be worked into for the shadow areas, and white for the areas of highlight.

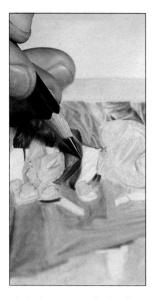

Shadows are worked up from the areas of deepest colour as here, *above*, the artist works black into the edges of dark brown shadows.

6 Soft greens, yellows and oranges were laid with upward strokes across the area of the sky to emulate the movement of smoke. These are then worked over with a plastic eraser, *left*, the movements following the direction of the pigment, gradually smoothing, mixing and burnishing the colours into the background. The smooth effect given by the eraser aptly conveys the sensation of wispy smoke.

7 To enable the artist to lay colour into small areas with greater accuracy and with relatively sharp definition, a typist's stencil was used as a template, *left*. He then fixed the drawing with fixative.

8 Once the fixative had dried, where colour had become almost too heavy, areas of compacted pigment were scratched away with a designer's knife, used very delicately *above*. This technique gives the colours a wonderful translucence.

9 A stencil is also very useful for burnishing pigment in small areas, acting as a very precise yet movable mask. Here, *left*, the artist uses it to great effect as an aid to achieving the same burnished effect that he has in the sky, thereby creating a textural link throughout the whole composition.

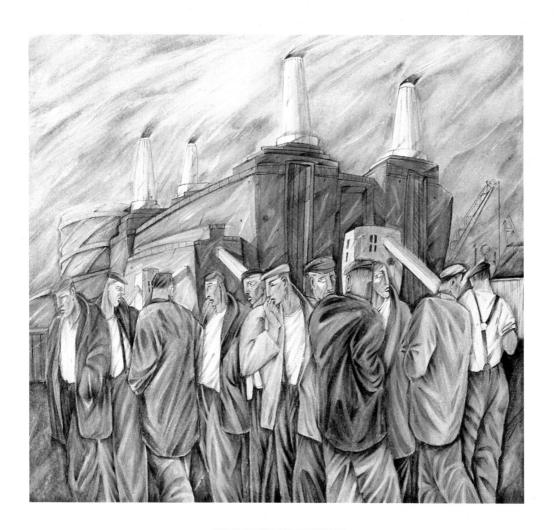

Battersea Power Station

10 Texture predominates in this composition, created by directional burnishing and the exaggerated folds in the workers' clothing, providing a unity throughout the image. It

invigorates the elements of the compositon and at the same time heightens the sense of tension glimpsed in the faces of the men.

CHAPTER ELEVEN

IMPRESSED LINE

There may be times when you want to produce a slightly different texture, either to pull out and raise delicate details in your image, or for an overall effect to heighten the colour and life in your drawing. Interesting results can be obtained in a number of ways to modify the colour and textural qualities of your given surface, by embossing the paper. The techniques fall into two main categories, resulting in either positive or negative texture. Neither texture can be created with damp paper or with water-soluble pencils.

There are certain types of paper which respond better than others to embossing techniques; these tend to be raggy and fairly soft. Very hard papers or papers with 'china' surfaces have a highly-compacted fibrous structure and do not 'give' as easily. But experimentation is the only way to push a paper to its limits, so try out all types of paper.

With positive texture you alter the entire surface quality of the paper by raising the level of the surface. A resilient but fairly soft paper will react best to this technique. Taking a textured surface such as a heavily grained piece of wood, or a brick, hold your paper over the texture and rub gradually over the paper surface to impress the underlying texture into your paper. This can be done prior to adding colour, using a smooth metal-tipped or plastic burnisher, or it can be done in conjunction with laying the colour, by the pressured action of the coloured pencil. Various papers will react in different ways to the textures they are placed on and to the subsequent treatment that they are given and it is advisable to experiment. Do, however, try to use gentle pressure to begin with, especially with a burnisher, and gradually build up the weight of your strokes and, ultimately, the depth of the texture. It may be useful to work in small areas rather than trying to control a large piece all at once because it is easier to control pressure over short strokes and a mistake could result in you tearing the paper. Gradual distortion of the paper's surface can, however, produce interest in both the texture and colour uptake of your work and offers a further visual dimension to the strictly two-dimensional.

The technique that gives you a negative texture is particularly useful, enabling you to create very precise, fine white linework within a coloured area, something which is quite difficult to achieve. White seldom remains pure in coloured pencil works because the pigment is semi-opaque and, however, it is applied, colour will show through it even if it is only an off-white effect from the paper used. White pencils also have a habit of becoming tinted, by picking up coloured pigments, or producing tinted effects from their proximity to colour, which can reduce the clarity of the image. Sgraffito can produce some interesting effects in white, but the colour has to be laid heavily in order to produce a solid base from which to scrape pigment or

Frottage and impressed line Above are two examples of creating texture by rubbing colour over paper on different surfaces. The top illustration was done over a brick wall and the sample above was coloured over fabric. This technique can produce a rich and unusual effect, particularly when the

layers of colours are burnished over a variety of surfaces. The degree of pressure exerted by the pencil point can be altered to create still more subtle effects.

incise lines, and since some pigment will always remain pressed deep into the texture of the paper, you are not guaranteed to produce a pure white line.

The only way to ensure a pure white line is to create a negative line which lies beneath the surface of the paper and remains clean while pigment is being applied on top. This is a negative or impressed line. It is simple to use, quick and clean, and the result can be stunning. Having chosen a fairly soft paper, take a tracing of your image and stick the tracing on the paper with masking tape. Then, using a hard graphite pencil point or a metal

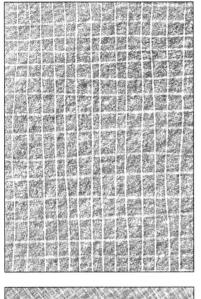

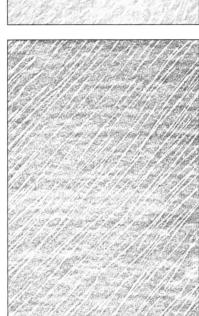

Impressed line

Line can be impressed into paper with any number of sharp objects drawn over a sheet of paper laid on top of the actual drawing surface. The example, far left, was done with a pencil, and the artist made the marks, left, with his finger nail. Below far left, lines were impressed into paper and then a layer of orange was laid over it. A second series of lines was impressed into the orange and then covered by red, revealing streaks of orange beneath it. Below left, lines were impressed into the paper, and covered with layers of dark blue. Each layer had lines impressed into it so that the end result is one of many lines texturing the pigment.

point, press down heavily (but not so as to tear the tracing or distort the image) and draw in all the lines that you wish to remain white. These are in effect being pressed lower than the overall surface texture of the paper. Then if you wish to draw in other guidelines for colour, slip a piece of transfer paper under the tracing and trace down the colour lines.

Having removed both sheets you will be ready to apply colour. This must be done carefully and not with a very sharply pointed coloured pencil because this may inadvertently get caught in the impressed line and

destroy the effect. Using soft movements over the area with colour you will gradually see a filigree of white lines emerge. Once the colour is laid you may find it necessary to rework the areas near to the white 'gutters' – perhaps darkening the tone on the edge of the white line a little to achieve a heightened effect in the dimensional contrast between the colour and the white. This method is extremely useful for depicting fine linework such as the veining in leaves and insect wings, or the crazing of ceramics, or surfaces that have delicate linear constructions, such as lace.

Still Life with Onions

The striations on the translucent layers of onion skin are an ideal pattern to depict using impressed line. The artist traced the outline of the onions and their markings on tracing paper laid over the final drawing surface, pressing hard with a graphite pencil. The depressions left in the paper became an integral part of the finished drawings. It is important to envisage the final structure of the colour composition before you start impressing because impressed lines are not easy to remove or disguise.

1 After outlining the form of the onions on the drawing surface in brown pencil, the artist then laid tracing paper and, with a graphite pencil, drew the lines of the onions, pressing hard on the paper, *right*.

2 When the lines are all drawn the artist removes the tracing paper and reveals a network of indented gulleys in the surface of the paper. These impressed lines become an inherent part of the image and will alter the visual effects of any coloured pigment applied later, *above*.

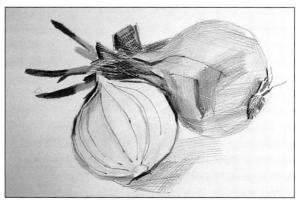

- **3** Greens and browns are added to the forms, applied parallel to and across the impressed lines to exaggerate their appearance, *above*.
- 4 As more pigment is added, the lines become more dominant only where colour is very heavily pressured does it penetrate the impressions, *left*.

Hatched areas of impressed line emphasize the papery quality of the dried onion skin and its surface pattern, *left*.

The finished drawing shows how successfully colour and form can be emphasized with impressed lines. The lines on the halved onion parallel the contours on the skin of the whole onion, creating a natural harmony.

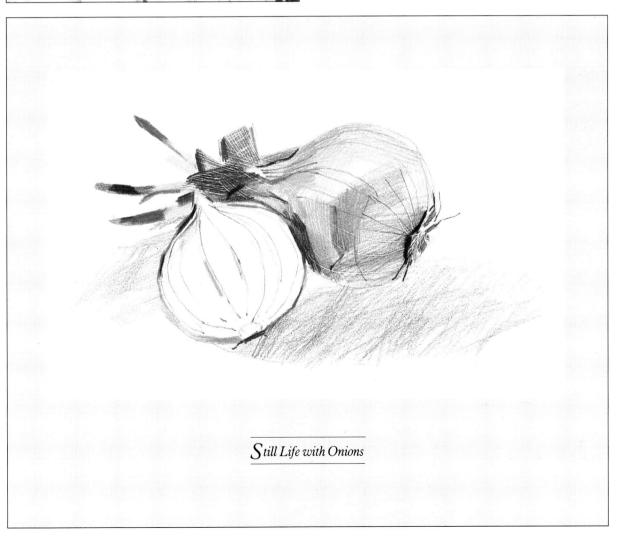

CHAPTER TWELVE

ANCILLARY TECHNIQUES

There are numerous techniques that you can use as an aid to creating a highly finished, as opposed to freely drawn, coloured pencil work. All illustrators have their methods for the design and construction of a drawing – some may have more general uses, others may not, but there are really no right and wrong ways. The following tips suggest 'mechanical' methods which may prove useful as alternatives to working in a sketchy manner.

Guidelines

Right, lines drawn around a given area of a composition are often a sufficient guide to the form of the drawing at the sketch stage, and create a boundary in which to work.

Cardboard masks

Left, using a large pair of 'L'-shaped cardboard pieces to create an adjustable mask, it is easy to arrive at a variety of compositions and to decide just how big the image area should be. A small pair of 'elbows' will also enable you, while drawing on location, to determine quickly the area of sketch to be explored.

TRANSFERRING BY GRID

From whatever point you start drawing there will come a time when you have to either enlarge thumbnail sketches or transfer a drawn or photographic image onto the final surface. You may want to transfer to scale or may have to alter the proportions and size of your sketch to fit the size of your paper. However, most people find great difficulty in translating a small sketch into a large image or reducing a sketch without guides, and the following are a number of simple techniques to make the task easier.

When enlarging a source of reference it becomes more difficult to maintain accuracy and control the larger the finished area. If you are going to attempt to draw a larger version of a small sketch in a free style you will have to mount or stretch your paper onto a board, so that you can tip the drawing at an angle. This is because if you put a large piece of paper on a flat table and proceed to draw on it you will find that your

perspective converges at a point at the top of the sheet farthest from your view. But by tipping the drawing forward you will keep the image in the same plane as your field of vision and avoid this problem.

A simple method of transferring a sketch either of the same size as the finished image or on a different scale is squaring, a technique which can be seen in preparatory cartoons from the Italian and German Renaissance, and in Dürer's woodcut of a man drawing a recumbent woman through a framed network of squares onto a piece of paper with a grid drawn on it.

Take a sheet of tracing paper and place it over the original sketch. Mark the outer edges of the original sketch and measure the frame, then divide each side into equal subdivisions. If you are enlarging the sketch to quite a big size, small squares will be necessary; if the finished image is going to be smaller than the sketch then the grid should be proportionately larger. Drawing across the image, join the subdivisions on the vertical

Transferring by grid

A successful method of recreating a good sketch is to square up the image area with a grid, right. Draw a second, large grid on the final work surface and transfer the detail from the original, square by square. This technique is a useful way of getting all the elements in their correct positions while increasing scale. It is often used on large areas where maintaining a sense of accurate perspective is most difficult. Grid lines drawn lightly in graphite will either be covered by the pigment or can be rubbed out while you are drawing.

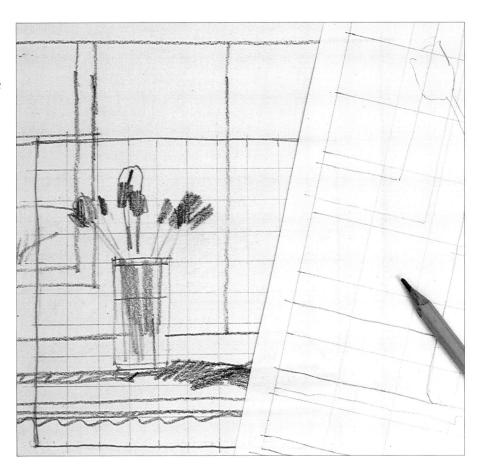

axes and draw lines joining the equal points on the horizontal axes. Then construct a similar grid on your drawing surface.

If you are doubling the size of your reference material, each square will have to be twice the size of the grid square on the sketch, and half its size if you are reducing the size of the sketch. Use a graphite pencil to draw the grids. The lines need not be heavy and they can be either covered over or rubbed out at a later date.

Once the grids are constructed you can use the squares as a ready method of checking the position of each element of your drawing with that in the appropriate square in the sketch. You are, in effect, breaking down the large-scale problem into a composite of smaller, more manageable areas.

This method is also useful if you want to block in a background with a decorative motif or a repeat pattern, because it will enable you to control the regularity of such a design.

TRACING PAPER

You may also find it helpful to first create the structure of your drawing in line form on a surface other than the final surface, and transfer it only when all the design decisions have been made. This will prevent you from having to make too many corrections on the drawing itself, particularly if you are using a heavily textured paper, because coloured pencil pigment is not the easiest substance to remove from a grained surface. Experiment with drawing your grounding lines with an ordinary graphite pencil on a sheet of tracing paper. It is quite a pleasant surface to work on because its very fine-textured surface tends to soften the pencil point, allowing a fluid pencil line to be created.

Drawing on tracing paper will enable you to alter shapes with the minimum of fuss and, indeed, if the drawing is large or particularly complex, it is often quicker to draw sections of it on tracing paper and join them together later. If you have made any mistakes you adhesive tape which will take pencil line easily. It is useful when creating composites because it is virtually invisible.

Gradually, all the elements of the drawing will come together on the tracing and these may then be transferred to the drawing surface.

TRANSFERRING TRACES

There are a number of different ways of transferring traced images. One of the simplest is to work over the reverse side of the tracing following each drawn line

can cut them out and patch in new tracing paper with with chalk, charcoal or graphite. Then turn the tracing magic tape. This tape is a matt-surfaced, translucent over and lay it down on the drawing surface, and retrace along each line using a sharp, reasonably hard pencipoint (if you use a pencil which is too soft, you will enc up with a very furry line). The whole image will ther have been traced down onto the drawing surface, ready to be worked up in colour.

> Alternatively, you can buy what is known as transfer or retracing paper. This is either tissue paper coated with very soft conté crayon, or a manufactured versior of the same thing. It is produced in black, white, sienna and yellow. The paper is placed with the pigmented surface face-down on the drawing surface. Your drawr

Graphite pencil

Graphite pencil lines are often used to delineate shape or to map out areas of colour, left. Although ordinary soft lead pencils (HB or B grade leads) are perfectly adequate, some artists prefer to work with pure graphite pencils. However, coloured pencil does not always cover graphite lines so, if they seem to be rather heavy, erase over the lines to soften them before colouring up the drawing.

Using transfer paper

1 A very efficient way of drawing a design in pure line without having to use an eraser on the paper surface to remove unwanted marks is to use retracing or transfer paper. The drawing is first made in line on the transfer paper, above. The paper is then placed over the final drawing surface, its pigmented side face-down. Carefully following each line with a sharp point – either a hard pencil or a metal point the design is retraced line by line.

tracing is then put on top of it and redrawn line by line using a pencil or a sharp metallic point like that on a pair of dividers or, for a very fine line, a pin. Metal points have the advantage over pencils in that they don't wear down, tend to be very precise in their line and leave no surface dust which, however careful you are, will always end up on the surface of the drawing paper.

Once complete, lift the tracing and the retracing off the drawing surface and you will be left with an impression deposited by the chalk. You can easily make conté paper by rubbing a conté stick over a sheet of tissue paper. But although it can be rubbed off the drawing easily when it is no longer needed, it tends to be very messy to work with. The chalk dust on the manufactured transfer papers is less of a hazard, but these papers are more expensive.

POUNCING

Another system of transfer is known as pouncing and is really used for covering large areas even though it is time-consuming and fiddly. Having done your sketch, follow each contour with a pin, gradually pricking holes down each line at equal distances. When complete, place your sketch over the final drawing surface and gently rub coloured chalk through the holes. Carefully removing the original sheet you will be left with your

2 The transfer sheet is then removed to reveal a line drawing in soft conté deposited from the transfer sheet. This conté is very easy to remove and can be drawn over quite successfully without any showthrough right. Take care when retracing to anchor all the sheets firmly with masking tape and do not place too much pressure on your retracing implement because it may cause an impressed line effect which will be very difficult to mask over once colour is added.

Pouncing

1 The artist punches fine holes around the linework of the original drawing by poking through the paper with a pin. He is now using a small cotton sachet, which contains ground charcoal dust, to pounce the back of the drawing, below. The fine charcoal will sift through

the holes onto the drawing surface below, leaving a dotted outline. Take care to fix the drawing surface because any slight movement will result in the dots being misplaced.

2 When the whole drawing has been pounced, remove the top sheet to reveal the image outlined by deposits of dust, below. The technique produces a very light line which will not interfere with later layers of colour. The dust sits on the paper's surface and is mixed with the coloured pencil

pigment when it is applied and, effectively, disappears.

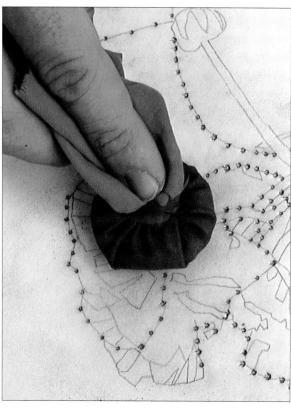

design deposited on the drawing paper in rows of tiny dots. This is not a popular technique because of the time involved in doing it, but it may be useful if you are working on a surface which will not take an eraser, such as plaster, or if you are using very pale colours which would not cover the remains of any tracing lines.

COUNTERPROOFING

this has to be transferred to the counterproof. Take the versed – it therefore has rather limited applications.

sheet of drawing paper that you are going to use for the final work and gently moisten its surface. (This can easily be done with a plant sprayer to leave a damp coating of water.) Then put the drawn outline facedown on the damp surface. Put the two sheets in a press or under a weight and allow them to dry a little. The length of the time this takes will have to be determined through practice with different papers, but once the Counterproofing is another fairly simple method of paper starts to dry out, remove the original sheet and direct transfer. With a soft graphite pencil draw the you will find that the drawing has been transferred to outline of your image onto a reasonably smooth surface. the moist paper. Although this is a simple method of Be careful not to dust off any surplus graphite because transferring, its disadvantage is that the image is re-

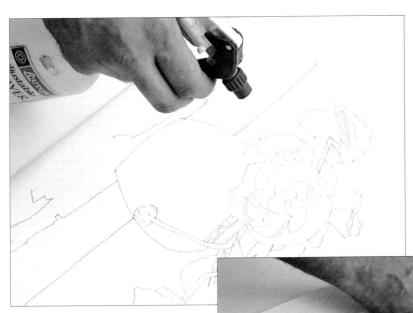

Counterproofing

1 Counterproofing is another method of transferring a tracing onto the final surface. Using a plant spray, gently squirt a delicate haze of moisture over the surface of the drawing. Do not get the paper soaked or leave uneven pools of water on it because these will create smudged effects. The water is used as a carrier to bond the now moistened pencil pigment to the absorbent surface of the next sheet of paper.

2 Place the moistened sheet face-down on the new, dry surface. Rub over it gently to press the pigment to the dry sheet and ensure that the bond between the two sheets is complete, without air bubbles. Further pressure can be applied with a regular motion of the hand, working from the centre of the drawing outwards to force air to the edges. If you intend to counterproof on a regular basis, it will be worth investing in a simple book press for this part of the process. When you separate the two dried sheets the reverse image will be fixed onto the second sheet of paper.

LIGHT SOURCES

Other techniques for tracing images involve a light source. It is possible to tape drawings to a window and to trace over the original onto a fresh top sheet, using the natural light to shine through the paper. Ideally, however, you should use a lightbox – this is, basically, a box containing a light, over which lies a translucent sheet of glass, which diffuses the light, giving an evenly illuminated surface. By placing your drawing on the glass you will be able to see through your paper and trace the line-work directly onto a fresh sheet of paper. The only disadvantage of this piece of equipment is that you can retrace to the original scale only and on no

other surface but a translucent one. It is also very costly to buy a commercial lightbox, particularly in view of its limited value, being used only in the preparatory stages of your drawing. You should therefore seriously consider making a simple version of a lightbox.

Commercial studios use a studio enlarger or overhead projector. They are very expensive pieces of equipment but both offer illuminated retracing and enlargement or reduction in one action. A Grant enlarger and epidiascopes are useful if you are working from transparencies, or to a vastly increased scale, but they are not necessary in the normal course of producing a coloured pencil drawing.

CHAPTER THIRTEEN

FIXING, MOUNTING AND FRAMING

The protection of any work of art must be given primary consideration if it is to endure the rigours of time and give long-term enjoyment. There are many simple methods of ensuring that a coloured pencil work will survive a reasonable length of time in its original state, but none is more fundamental than choosing the best possible materials in the first place. Most artists also try to make sure that all reasonable measures, even short-term ones, have been taken, to avoid the rapid deterioration of a work on which they have lavished love and time.

SHORT-TERM PROTECTION

The wide variety of papers may help you to achieve a large range of effects but they are not themselves without their own side-effects. Any paper that has an alkali or acid chemical content needs special care and attention at some point. Many papers, particularly cheap ones, or indeed some handmade papers, contain impurities that will not cause problems while the paper is kept in perfect atmospheric conditions, but if the paper is subjected to a high level of moisture, these impurities will react with disastrous results. Foxing, for example the brown patina that often appears on old paper – is a direct result of metallic impurities within the paper which react to moisture and which, over the years, gradually stain the paper's surface with rustlike marks. There are now many manufactured drawing papers which present no such problems and in the main these are pure rag papers. Specialist paper suppliers, and particularly manufacturers of vellums and parchments for archive work, will be happy to advise on this matter, though for everyday work good-quality drawing or watercolour papers should suffice.

No less important than the quality of the paper is the quality of the pencil that you are using. Very cheap coloured pencils are usually manufactured for children and have low permanence, but the better quality coloured pencils have a higher grade bonding medium and finer pigment purity. This results in brighter colour, better application and greater longevity without the risk of fading. It is not necessary to buy a vast set of coloured pencils when you are beginning, so concentrate on quality rather than quantity.

The life of your drawing will also be extended if care is taken in the handling of the materials. Try not to rub out mistakes with an eraser, because this just removes a layer of fibre from the paper's surface, creating a weakness in the paper which may develop other problems later. If you practise working with pale colour, applying darker hues as the work is built up, then the possibility of having to use an eraser will be greatly reduced. Use hard erasers only if the paper surface itself is hard, and where possible use a soft putty rubber.

When working with water-soluble pencils try to avoid using any water that may be even slightly contaminated.

you are working in the open air - but if you really want your work to endure it is much better not to soak the paper surface with any chemical agent. Do also avoid rubbing at all on any damp surface because this will destroy the fibre structure of the paper's upper layers.

Lastly, when working up a large area you will often find your hand resting on the paper just below the area to which you are applying colour. This can result in smudging and, because hands are to some degree oily, they will leave marks which may prove difficult to eradicate or cover over at a later date. When working on thin papers you will also find that the heat of your hand will cause the paper to buckle. To avoid all these problems simply slip a fairly stout sheet of paper or light board between your hand and the working surface. This can stay in position of its own accord or be taped to the surface with masking tape if you are going to be working for some time in one area. There is little else you can do while working to maintain the good condition of your drawing, but for long-term protection there are a number of protective measures.

FIXING

Once your drawing has been completed, it will need to be protected. Pencils vary in their bonding agents some are waxy, whereas others are chalky; some provide a matt finish, others a gloss. But all smudge under pressure and so it is important to fix the pencil drawing in order to stop the removal or damage of the drawn surface. To do this you have to spray the surface with a protective bonding agent - a kind of lacquer. A number of fixatives are manufactured specifically for pencil work.

Pin your finished work vertically and spray it evenly with the fixative. Directions on the can usually stipulate holding the can about 30cm (12in) away from the image to achieve an even coating. If you hold it too close it will saturate the surface with the substance, which may run and streak your work, or sit in pools, when it takes time to dry and can act as a blender on colours and destroy the work. The secret is to get an even, unnoticeable coating, which is possible if you spray at a diagonal angle. On thin papers it is possible to spray on the reverse side of the paper to fix the drawing, and not This is sometimes easier said than done – particularly if over the actual pigment; on heavier paper, or when you

FixingBy holding a can of aerosol spray fixative vertically at a short distance from the drawing surface, a good even coating can be applied, *left*.

Fixing from behindFine papers are often very successfully fixed from behind, *above*, by spraying a light coating over the reverse side of the drawing.

have used a considerable amount of pressure on the pencil work, spray over the drawing itself.

Use only good-quality fixative and try not to resort to sprays such as hairspray, unless the work is required for sketch notes only, in which case it works well for temporary protection. Apart from ordinary pencil fixative, a number of heavier lacquer finishes can also be bought in spray form. Either matt or gloss sprays provide a good strong protective coating, but the heavier the spray the longer it will take to dry and most gloss fixatives suggest two or three coats over a 24-hour period.

Fixing the pencil pigments will also prevent a 'wax bloom' occurring, where heavy pressure and excess bonding agent deposited on the paper's surface result in a haze forming over the drawing. If a 'wax bloom' has already appeared, fixing the drawing will stop it from happening again.

After your drawing is fixed it should be stored flat and interleaved with a sheet of non-acidic film or tracing paper. It is not a good idea to roll pencil drawings and certainly not if they have been heavily lacquered because the pigments will tend to drop off or smudge. Ideally you should not stack too many drawings on top of each other because this may compact the coloured pencil pigment and damage the way in which the pigment sits on the paper's surface. Drawings will last well if stored in this way in wooden drawers or a plan

chest, away from any obvious sources of humidity, but for long-lasting protection framing is best.

FRAMING

Coloured pencil work cannot be trapped directly behind glass because this not only crushes the surface pigment but also compresses the paper's texture. Therefore a mount is necessary and, indeed, will offer added protection even if you are not going to frame your drawing. Mounts are cut from strong, specially manufactured board. Such boards are available in many thicknesses and with a huge variety of surfaces, ranging from bonded paper in a wide selection of colours, to linen and chinese lacquer. If you turn the board on its edge you will see that it is composed of layers of thinner boards bonded together, with a finer surface adhering to the top. Be aware of this construction when cutting your mount because it will often happen that, although a clean cut may be made through the laminated boards, the surface material, which is of a different structure, will snag and tear. It takes practice to know which materials cut well and this is not an easy operation.

Measure your drawing and consider its content. Many close-up views require a fairly modest area of mount to achieve a pleasing frame, but you will find that some images, such as a work with a very dramatic perspective, are best set in a wide mount. This, in effect, heightens

the sense of breadth and vision and takes the eye from the foreground to an infinite point on the horizon.

The scale of your mount can do a great deal to enhance the content and style of your work. Cutting the mount will be the most difficult task you will have to master. There are many cutting kits which range in size and quality, but try to ensure that you have a good blade holder and a fixable ruler which can be attached to your work surface and against which you can butt the mount. Having marked your areas on the board with a mediumsoft graphite pencil, place the board in a holder and draw the blade towards you. Always make sure that the blade is sharp, otherwise it may cut the board or, more often than not, tear the top surface. Most people prefer a bevelled edge to the inner mount edge, but a vertical edge is easier to practise with in the initial stages. Some artists prefer to leave a border between the image area and the mount. This can look attractive, particularly if the edge of the drawing has been tightly worked, but there is no hard and fast rule on this matter and often a mount may be used to mask over the border of a very rough drawing.

Place the drawing behind the mount and carefully fix it in place with a few small pieces of masking tape. Once it is square and in the right position, remove the small pieces of tape and fix the drawing in place by running right around the edge with masking tape. It is preferable not to leave too much paper beyond the extent of the mount when fixing it down. Should the drawing warp a little, attach it just inside the back of the mount and it will remain in place. If too much paper has been left behind the mount the tension will be lessened and the paper will buckle between the backing board and the glass.

The drawing is now ready for its frame. Simple glass clip-frames can be used and are easily made. You can either buy the components individually at most good art shops or, alternatively, cut your mount to a standard shape and buy a ready-to-hang kit. Always clean glass with an anti-static spray or fluid and wipe it with soft cloth before assembling your picture. It is generally desirable to use glass on most paper-based works; some acrylics or plastic can be used in certain circumstances, but many exacerbate the oxidization process in any impurities in the paper's make-up.

Using a bevelled metal ruler Mount boards and slips can

Mount boards and slips can easily be cut using a bevelled metal ruler and a sharp craft knife, *above*. It is important that the cutting edge is metal, and also that the ruler is bevelled at a good angle to enable you to make a consistent cut in the mount.

Framing

Right, using a mitre rule, the angle of a frame corner can be measured accurately and drawn across the wooden bar. Centre right, a mitre clamp is fitted to a working surface to hold the frame in place while the corner cuts are made. Far right, the clamp on the mitre vice is also used to hold the two pieces of frame in position once they are glued, while a panel pin is knocked in place from either side.

If you have a frame made for you then make sure that the glass fits snugly in the rebate behind the front edge. This will help to prevent small insects or moisture getting in from the front. Place the glass into the frame and drop the mounted drawing on top.

Behind the drawing you will need a backing board of some sort. This is usually plywood or hardboard and will give not only excellent protection to the reverse of the work but also added structure and strength to the frame itself. The board is held in place by knocking small framer's tacks down into the inside edge of the frame at a 45-degree angle.

With everything held firmly in place, run gummed brown paper tape over the back of the frame from its

Framing materials

A selection of materials used for framing are displayed, right. 1 An Emo interchangeable metal frame: 2 An Emo framer's pack, consisting of a piece of glass, fibre board and a few small clips: 3 A ready-made wooden frame; 4 A bulldog clip; 5 Spring clips; 6 Mirror clip; 7 A Kulicke metal frame kit; 8 A Daler metal frame kit; and 9 A Hang-it frame

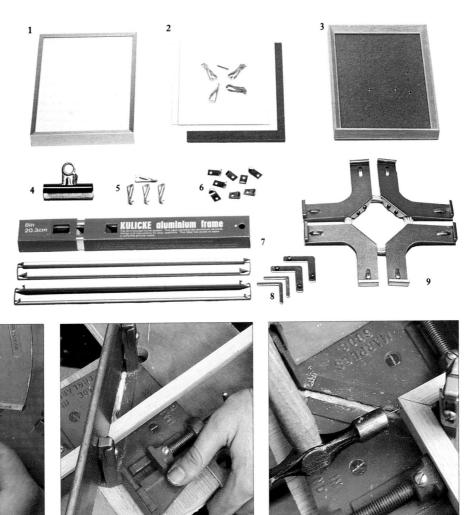

onto the board itself. Make sure that each edge is firmly sealed and that the corners of the tape overlap to give complete protection at the reverse of the drawing. Small keyhole screws may be inserted one third of the way down the vertical side of the frame in the back edge of the frame itself. Using either a nylon picture cord or picture framer's wire, the work will be ready to hang. Test out the length of wire you need before finally knotting or twisting it in place.

today, from wide, ornately carved or plastered wood, to most of these simple principles you will extend the simple metal, plastic or wooden strips. The choice is possible life of your drawings for the enjoyment of all in yours but when in doubt it is usually best to select years to come.

edge over the join with the backing board and down something simple and, unless you wish to take up framing on a regular basis, do have the basic elements cut by professionals.

There is little more you can do to protect your works, except to consider where you hang them. Try to avoid rooms where temperature fluctuations are great, or the moisture content is high. Inside walls offer the most stable conditions, but keep drawings out of direct sunlight to avoid fading, and away from heat sources. Having taken the trouble to create your coloured pencil There are obviously many varieties of frame available works it makes sense to look after them. If you stick to

Glossary

ADDITIVE COLOURS Red, blue, and green – the primary colours of light that can be mixed to create all other colours.

BLENDING Fusing colours either with a solvent, such as water, or by rubbing over them, or by colouring over them so that no joins or pencil marks are visible

BLOCKING IN Establishing the main forms and composition of an image with areas of colour and tone.

BURNISHING Rubbing over a colour with an eraser, a paper stump, a tortillon, or even another colour, to create a sheen on the underlying colour.

CHINA PAPER An art paper coated with a fine layer of white china clay, which gives it a translucent appearance.

COLD-PRESSED A term applied to high-quality drawing or watercolour paper, referring to its surface, which is medium-smooth. Also known as Not (Not Hot-Pressed), this paper is created by laying sheets of paper on top of each other without felts between them, so that they become slightly compressed and smoother in texture than Rough paper, but not as smooth as Hot-Pressed paper, which is passed through hot metal rollers.

COMPLEMENTARY COLOURS Those colours that are opposite each other in the colour wheel, such as red and green, violet and yellow, orange and blue. Each one increases the intensity of the other when they are juxtaposed.

COUNTERPROOFING A method of transferring a drawing from one surface to another in which the drawing is made with a soft, graphite pencil, and a damp sheet of paper is pressed flat onto the drawing until it dries. The second sheet of paper takes up the surplus graphite from the drawing and is imprinted with a reversed copy of the drawing.

CROPPING Cutting out the vertical or horizontal margins of an image to exclude unwanted elements or to emphasize and focus on particular aspects of the image.

CROSS-HATCHING A technique of criss-crossing lines of colour to build up tone, used especially to darken areas such as shadows.

FIXING Spraying a substance onto a drawing so that the colour does not smudge or drop off the paper. Fixatives are varnishes sold in the form of aerosol cans or in a form to be applied by a mouth diffuser.

FOXING The brown discoloration of paper that occurs when the impurities in the paper react to a damp atmosphere.

FROTTAGE A technique used to produce texture in colour whereby a point medium, such as pencil, is rubbed over paper laid on top of a textured surface, such as a wooden table, or a coin.

GESSO A highly absorbent, white ground, made from gypsum or chalk. it is used to cover wooden or hardboard panels, or paper, to produce a white, textured or smooth surface depending on how it is applied.

GHOSTING The application of a thin veil of colour over a base image or colour so that the image shows through.

GRAPHITE A carbon which is used with clay in the production of coloured pencils.

GREY SCALE The tonal scale of greys from black to white.

GRID In coloured pencil drawing, a grid is an area of cross-hatched colour.

GROUND A surface specifically created to make the paper suitable for drawing and painting on. It could be gesso or a layer of coloured pigment.

HATCHING A drawing technique using parallel lines to indicate form, tone or shadow.

HOT-PRESSED A term that refers to manufactured paper which is glazed and smoothed by the heated metal plates of a roller system.

HUE A tint or shade of a colour.

IMPRESSING A technique of grooving marks into the paper's surface to provide an outline or to create texture within a drawing.

IRON-OXIDE PAPER A paper coated with iron oxide on one surface so that when it is placed coated face down onto another surface, a tracing can be redrawn on top of the reverse side and the drawing is simultaneously transferred to the underlying surface.

MACHINE-TEXTURED PAPER
Machine-manufactured paper which
is impressed to create a certain
texture, such as that of linen, or
elephant hide.

MASKING Refers to a number of methods of obscuring specific areas in an image that you do not want coloured as you work on another, adjacent area.

MONOCHROME An image painted or drawn in black and white, or shades of one colour.

NEGATIVE SHAPES The shapes created by drawing or painting around an object, rather than painting the object itself.

OPTICAL MIXING The juxtaposition in an image of blobs of colours so that they intermingle, but the pigments do not actually mix – at a certain distance they mix in the viewer's eye only. For example, blue dots interspersed with yellow create the impression of green.

OVERHEAD STROKES Strokes applied with a pencil held between the thumb and forefinger. Holding the pencil this way the artist can exercise the greatest control and accuracy over the pencil's marks.

POINTILLISM A method of applying colour in a series of dots rather than with strokes or in flat areas.

POSITIVE SHAPES Those shapes created by drawing or painting an object rather than the spaces around it.

POUNCING A technique of transferring a drawing in which the lines of the drawing are pricked at regular intervals with a pin, and then a sachet of charcoal dust is stamped along the lines, leaving a thin trail of dust on the underlying surface which reproduces the lines of the drawing.

ROUGH A rough drawing or sketch to be worked up at a later stage.

SATURATED COLOUR A term that refers to the density of a colour; if it is densely applied it has high saturation, and if it is lightly applied it has low saturation.

SGRAFFITO A technique of incising into the pigmented surface to create texture. Any type of mark can be created using any sharp instrument, from a pin to your fingernail.

SHOW-THROUGH The amount of paper or canvas that is left untouched by pigment or is covered by only a thin layer of colour, and is visible through the surrounding or overlying colour.

SIZE A gelatinous glue, sometimes of animal origin, such as rabbit skin glue, used to coat a surface to prepare it for priming, painting or drawing.

SQUARING A method of transcribing an object or figure onto paper by setting it up behind a screen of squares and then, working on grid paper, transferring each element in each square of the screen to the appropriate square on the paper.

STIPPLING Drawing, painting or engraving, using little dots of colour rather than flat areas or strokes.

STRAIGHT-EDGE An instrument with long, straight edges, usually made from steel or plastic. It is used to draw or colour against, to provide a straight line or hard edge of colour.

SUBTRACTIVE COLOURS Colours that absorb light rather that refract it – this term refers to the primary pigment colours and the colours produced by their mixture.

THUMBNAIL SKETCH A quick sketch of the position of the elements of a composition, and their colours, usually done on a very small scale, hence 'thumbnail'.

TONAL VALUE The density of tones in an image.

TORTILLON A stump of rolled paper or chamois, used to blend coloured pencil, charcoal and pastel.

UNDERDRAWING A preliminary drawing done in pencil or charcoal, over which the finished work is carried out.

UNDERHAND STROKES Strokes made with a pencil held in the palm of the hand and controlled by the thumb and fingers. The strokes produced are broad and sketchy and useful for covering large areas.

VIEWPOINT The angle at which an image is represented to provide the best aesthetic study or to emphasize particular elements in the composition.

WAX BLOOM The grey haze that forms over heavily burnished colour in pencil drawing. It is caused by the waxy bonding agent of the pigment being deposited in large quantities over the colour. It can be wiped away and prevented from forming again by spraying the drawing with fixative.

Index

Figures in *italic* refer to illustrations

Α

Additive colour mixing 34 Advancing colour 36 Aerosols, fixative 20, 20 Albambra Gardens 96-7 Ancillary techniques 159-65 Architectural drawing 12 Art knives 21

В

Backgrounds, hatching 67, 69 Bathers 86-9 Battersea Power Station 148-51 Beachboys 114-5 Berol china markers 17 Berol colour pencils 16 Bevelled metal rulers 170 Black and white 84 'Bleed' effect 118 Blending colour 49, 79, 82-3, 84, 135 Blending pens, colourless 118-19,119 Bloom, wax 146, 169 Bonding agents 8, 168 Brushes for water-soluble pencils 118 Burnishing implements 14 Burnishing stencils 22

\overline{C}

Caran d'Ache colour pencils 17
Cardboard masks 160
Chalk, pouncing 163-4, 164-5
Charcoal pencils 17
China markers 17
Cleaning eraser 23
Colour 12, 33-6
additive colour mixing 34
blending 49,79, 82-3, 84, 135
burnishing 143-51, 144-7
colour wheel 35
composition 35-6, 36-7

creating 77-99 cross-hatching 787 and form 101-15 gradations 80 hatching 58, 59, 60, 62-3, 63 impressed lines 155 intensity scale 82-3 juxtaposed 105 lavered 83-4 and movement 46 and paper texture 78 perceived colour 34-5 pigments 18-19 reflected 105 saturation 80-1, 82-3 sgraffito 135, 137 spectrum 34, 35 subtractive colour mixing 34. 34 texture 84 tonal ranges 80 water-soluble pencils 119-20. 119-23 Colour form association 102-3 Colourless blending pens 118-19.119 Combination erasers 23 Complementary colours 35 Composition 35-6, 36-7 Conté charcoal pencils 17 Conté crayons 16 Conté paper 163, 163 Conté pastel pencils 16 Conté Pierre Noir drawing pencils 17 Conté watercolour pencils 16 Conté white drawing pencils 17 Counterproofing 164, 165 Craft knives 20, 21, 21, 40, 134, Cross-hatching 110-11, 57, 57-75, 58-9 and colour 787 and dimension 63 and form 58, 61 grev scale 61 and perspective 61 sgraffito 137 texture 58 tone 60 see also Hatching

Curved lines 45-6

Cutting mounts 170, 170

D

The Dancer 72-5
Diffusers, fixatives 20, 20
Dimension
colour and 85, 103
hatching and 63
lines and 44, 45-6
sgraffito 135
Dots, drawing, 41-2, 41, 84
Dürer, Albrecht 160

E

Eiffel Tower 108-11
Embossed papers 27, 27
Embossing techniques 154-5
Engraving 58
Enlargers 165
Enlarging 160-1, 161
Epidiascopes 165
Equipment see Materials; Tools
Erasers 14, 168
blending colour with 49
burnishing with 144, 145
types 22-3, 23
uses 22-3
Espadrilles 90-1

F

Faber-Castell colour pencils 17 Faber-Castell pure graphite pencils 17 Faber-Castell water-soluble pencils 16 Fairground 98-9 Fitzmaurice, Christine, Portrait of Alice Linell 9 Fixatives 20, 20, 146, 168-9, 169 Fixed drawings 168-9, 169 form 12 colour and 101-15 hatching and 58, 61 lines and 44, 46 Format 35-6 Foxing 168 Frames 36 Framing drawings 169-70, 170-1

Frottage 154

G

Gesso Boards 40, 134, 135 Gesso grounds 30-1 Gloss fixatives 169 Grant enlarger 165 Graphite pencils 8, 17, 162, 164 Grey scale 83 cross-hatching 61 Grids hatching 60 transferring by 160-1, 161 Grounds, gesso 30-1 Guidelines 160 Gum grasers 23, 23

Н

Hairspray 169 Handmade papers 24-6, 168 Harbour 106-7 Hard erasers 22-3, 168 Hatching 10-11, 57-75 backgrounds 67, 69. and colour 58, 59, 60, 62-3, 63 with different pencil points 60 and dimension 63 and form 58 highlights 63 sgraffito 137 shadows 62.63 texture 58-60 tone 57 see also Cross-hatching Highlights burnishing 144, 146 colour 102-3 hatching 63 masking 121 History of coloured pencils 8 Hues 35, 35

I

Illumination 85 Impressed line 153-7, 154-5 Ink erasers 23 Intensity scale 82-3 Irises 66-9 J

Jamie 54-5 Juxtaposed colour 105

K

Kneadable erasers 23, 23, 54, 68, 168 Knives cutting mounts 170, 170 mixing pigment with 54 sgraffito 134-5, 136 sharpening pencils 20, 21-2, 21, 40 types 21-2, 20-1

L

Lacquer 20, 168-9 Landscape drawing 12 Lavered colour 83-4 Leads coloured pencils 8 graphite 8 qualities 17-18, 40-1, 40, 60 sharpening 21, sizes 19 Leonardo da Vinci 8 Light and form 102-3 Light sources, transferring traces 165 Lightboxes 165 Lines 39-55, 40, 41 characteristics 42-4 curved 45-6 and dimension 44, 45-6 drawing 42 and form 44, 46 impressed 153-7, 154-5 length of 46 and movement 44, 45-6 paper surface and 43 and paper texture 45 scale 46 speed 46-7 texture 41-3, 44-6, 45, 46 and tone 44 see also Cross-hatching; Hatching

M

Machine-made paper 24, 40 Magic tape 162 Marker pens 118, 119 Masking fluid 121 Masking tape 170-1 Masks, cardboard 160 Materials 15-31 choosing 40 erasers 22-3, 22-3 fixatives 20, 20 paper 24-7, 24-7 pencils 16-7, 17-19, 19 sharpeners 21-2, 21 see also Tools Matt fixatives 169 Mitre clamps 170 Mouldmade papers 24-6 Mount board 170-1 Mounting drawings 169-70, 170 Mouth diffusers, fixatives 20, 20 Movement, lines and 44, 45-6

N

Non-acidic film 169

O

Optical illusions 60 Overhead strokes 42 Overhead projectors 165

P

Palette knives 31 Palm 138-41 Paper 14 burnishing 144 colour and 78 counterproofing 164, 165 impressed lines 154-5 line quality and 43, 45 protecting 168 qualities 40 sgraffito 134, 135, 136 stretching 28-31, 28-9 texture 45 transfer paper 162-3, 162-3 types 24-7, 24-7 for water-soluble pencils 118 Paper stumps 143

Peel-off pencil erasers 22 Pencils charcoal pencils 17 fixative 20, 20, 168-9 graphite pencils 8, 17, 162, 164 holding 42 pastel pencils 16 permanence 168 sharpening 18, 21-2, 40 types 16-7, 17-19, 19 water-soluble pencils 12, 16, *17*, 18-19, 117-31, *120-3*, 168 watercolour pencils 16, 17 Perceived colour 34-5 Perspective 46, 160, 161 cross-hatching and 61 Pigment sticks 54 Pigments 8, 18-19 colour theory 34-5, 34 paper and 24 removing 54 solvents 118 tonal ranges 80 see also Colour Plantation 70-1 Plastic erasers 23, 23 Pointillism 41-2 Pompeii 133 Portrait of Alice Linell (Fitzmaurice) 9 Pouncing 163-4, 164-5 Primary colours 34, 34, 35, 59, Projectors, overhead 165 Protecting drawings 168, 171 Putty rubbers see Kneadable erasers

Pastel pencils 16

R

Rag papers 25, 118, 168
Ranunculus 124-7
Razor blades 21-2, 21, 134-5
Reducing colour 36
Reducing 161
Reference material 12, 160-1
Reflected colour 105
Reflection 128-31
Reflection, burnishing 143, 144
Renaissance 160
Repeat patterns 161
Retracing paper 162-3
Rexel Cumberland colour

pencils 16
Rexel Cumberland watercolour pencils 17
Rome 133
Rulers, cutting mounts 170

Sanding pads 21-2, 21

Sandpaper, preparing paper

S

with 31 Saturation, colour 80-1, 82-3 Scalpels 20, 21, 40, 54, 134-5 Schwann-Stabilo fat-leaded pencils 17 Schwann-Stabilo pastel pencils Secondary colours 34 Sets of pencils 19 Seurat, Georges 84 Sgraffito 133-41, 134-7, 154 Shadows 52, 53, 84 colour 104 hatching 62, 63 Shape 12 Sharpeners 1421-2, 21 Sharpening 14, 21-2, 40 Sidaway, Ian 13 Sketch pads 26, 27 Sketchbooks 14, 27, 118 Sketches 47, 47 'thumbnail' 35, 37, 169 Soft erasers 22, 23, 23 Soluble pencils see Watersoluble pencils Solvents blending colours 84 soluble pencils 117, 118, 119 Spectrum 34, 35 Speeds, lines 46-7 Sponges, preparing paper with Squaring 160-1, 161 Stanley knives 40 Still Life or Magic? 112-13 Still Life with Onions 156-7 Still Life with Shells 52-3 Still Life with Tulips 48-51 Stippling 42 Storing drawings 169 Stretching paper 28-31, 28-9 Strokes see Lines Subtractive colour mixing 34, 34 Sunset 64-5

Τ

Techniques 12
Texture
burnishing 146
colour 84
dots 41, 41
gesso grounds 31
hatching and cross-hatching
10-11, 58-60
impressed lines 153-7, 154
lines 41-3, 44-6, 46
paper 24-7, 40, 45
Thompson, Simon 10-11
Three-dimensional images 12
colour and 103

see also Materials

Tortillons 22. 118, 143, 144, 145
Tracing paper 160, 161-2, 169
Tracings
impressed lines 154-5
transferring 162-5, 162-3
Transferring by grid 160-1, 161
Transferring traces 162-5, 162-3
Tricia 92-5
Turpentine 118
Typist's erasers 22

U

Underhand strokes 42

W

Water-soluble pencils, 12, 16, 17, 18-19, 117-31, 120-3, 168
Watercolour paper 28, 40, 118, 168
Watercolour pencils 16, 17
Wax bloom 146, 169
White 84
White spirit 118
burnishing with 144-6, 145-6
impressed lines 154-5
Wooden pencils 8

Credits

Quarto would like to thank all those who have helped in the preparation of this book, especially Justin Scott for the use of his studio, Langford and Hill for the loan of materials, and in particular Rexel Cumberland for their generous sponsorship and contribution of materials to this book.

Contributing artists

pp 64-65, 70-71, 138-141, Alan Adler; pp 96-97, 112-113, Susan Alcantarilla; pp 86-89, 106-107, Adrian Bartlett; pp 48-51, 52-53, Chloe Cheese; pp 92-95, Paul Finn; pp 54-55, 98-99, 114-115, Elaine Mills; pp 148-151, Stuart Robertson; pp 77-85, Piers Sanford; pp 36-37, 38, 40-47, 56, 58-63, 66-69, 76, 78-83, 85, 90-91, 100, 102-105, 108-11, 116, 119, 120-123, 124-127, 132, 135, 136-137, 142, 144-147, 152, 154-158, 160-165, Ian Sidaway; pp 128-131, Stan Smith.

Other illustrations

p 6, with the permission of Ian Logan Ltd; pp 10-11, with the permission of Spectron Artists Ltd; pp 16-27, 118, 134, photographed by Paul Forrester; pp 28-29, 156, 158-160, 161-167, 169, photographed by Jon Wyand.